Hidden in Plain Sight

An Examination of the American Arts

MARTIN WILLIAMS

New York Oxford
OXFORD UNIVERSITY PRESS
1992

Oxford University Press

Oxford New York Toronto
Delhi Bombay Calcutta Madras Karachi
Kuala Lumpur Singapore Hong Kong Tokyo
Nairobi Dar es Salaam Cape Town
Melbourne Auckland

and associated companies in
Berlin Ibadan

Published by Oxford University Press, Inc.,
200 Madison Avenue, New York, New York 10016

Oxford is a registered trademark of Oxford University Press

Library of Congress Cataloging-in-Publication Data
Williams, Martin T.
Hidden in plain sight :
an examination of the American arts /
Martin Williams.
p. cm. Includes bibliographical references and index.
ISBN 0-19-507500-5
1. Mass media—United States.
2. United States—Popular culture.
I. Title. P92.U5W52 1992
302.23'73—dc20 91-33885

1 2 3 4 5 6 7 8 9

Printed in the United States of America
on acid-free paper

Acknowledgments

Portions of my remarks on Max Brand and John D. Mac-Donald appeared in the *Washington Post* in 1973 and 1988 respectively. My comments on Johnny Gruelle combine portions of an essay that appeared in the *Washington Post* in 1972 and *Children's Literature,* Vol. 3 (Temple University Press). Portions of "Celebrating Segar" appeared in *Cavalier* magazine and as the introduction to Volume 9 of *The Complete E. C. Segar* (Fantagraphics Books 1989). And the bulk of the essays "A Purple Dog, a Flying Squirrel, and the Art of Television" and "Tell Me A Story" originally appeared in *Evergreen Review* for September–October 1961 and June 1967 respectively, and are present here by permission of Grove Press. I am grateful to all concerned for the use of these pieces here.

Finally, the verses by Walt Kelly, "Wry Song" and "Mistress Flurry" are from *Pogo's Stepmother Goose* and are included here by permission of Simon and Schuster and Selby Kelly.

Washington, D.C. Martin Williams
November 1991

Contents

Hidden in Plain Sight

To See Ourselves

In its first century, the United States showed an inventive mechanical genius which expressed itself in everything from the steamboat and the sewing machine through the factory assembly line and osteopathic medicine. It also included, significantly, the phonograph and the motion picture. That observation about our history is generally acknowledged and domestically celebrated; indeed our Centennial celebration in 1876 was based on huge displays of those mechanical devices for which we were then known and through which we were willing to define our progress and our accomplishments.

We have spent our second century devising and exploring a dazzling, spunky array of *genres* and *sub-genres* of artistic activity—motion picture drama, jazz, a special kind of musical theater and its associated music and dance, the modern detective story, the comic strip, to name only the most obvious. But as a people, we have been singularly unwilling to number the best works in those genres among

our major accomplishments. It seems to me that the failure may be partly attributed to our intellectuals and academics.

If an American artist works with distinction in a traditional European art form, we will eventually give him his due. If we produce a Eugene O'Neill or William Faulkner, our intelligentsia will know them and know which are their major works. Charles Ives is perhaps a special case since he was so bold an avant-gardist that his reputation might have taken time to build in any culture. But if an American artist works in a *genre* we have created, we may give him his credit and praise of one sort or another, but still withhold such labels as "serious" or "artistic." If we produce a George Herriman or a John Ford or a Charles Mingus, we do not number them among our major artists, and our intellectuals will not be found designing and erecting an American pantheon to accommodate them. The problem is not only a matter of intellectual recognition but also of the education of our people—formal and informal— that follow on that recognition. To express the state of affairs in a single example, how many Americans know that aesthetically as well as mechanically the motion picture is ours?

European artists and critics have discussed and praised (and sometimes overpraised) our movies, jazz, comic strips, and other American arts, but there are several observations one might make about that activity. A French intellectual with Corneille, Racine, and Molière in his heritage, with established composers from Rameau through Debussy, with Hugo and Flaubert to his country's credit, can readily afford to relax and look around him. We Americans are apt to assume that we cannot afford such a relaxed look at our own aesthetic matters. We are still trying to prove ourselves, and trained in aesthetics based on European accomplishments, we apply the principles that tradition gives us only to those same forms of art from which it was derived,

and in which European artists have worked so well. We may judge Winslow Homer by the standards of Velázquez and Courbet, but we seem unwilling to apply similar standards to strip artist Cliff Sterrett.

I should acknowledge that there have been important exceptions among our own intelligentia. To cite a few of them, there is music critic R. D. Darrell, who was perceptively praising Ellington and Louis Armstrong by 1931; there is the standard critical history of the comic strip, Coulton Waugh's *The Comics,* from 1947; movie history goes back to Terry Ramsey's 1926 A *Million and One Nights;* and Gilbert Seldes had invited us to examine *The Seven Lively Arts* two years earlier.

Any thoughts of my own on all this—thoughts that I have considered worth committing to paper—have come to me rather slowly. They are based of course on my own responses to and interest in movies, comic strips, and the rest, interests that of course began in my childhood. A turning point came through my own writing and teaching on jazz, and a recognition that its problem with a serious acceptance in the United States not only came from the fact that it is an African-American musical idiom (it is that no matter who is playing it) but also that it is an American musical idiom. A second turning point came when I was speaking to an institute in jazz criticism in the mid-1970s and heard myself saying (without having given the matter much previous thought) that I did not think that anyone could truly understand jazz without understanding the other American vernacular arts.

Undeniably we have begun to allow the movies, the comics, and jazz into our academies, but we have allowed them in as "popular culture." It is surely significant that "popular culture" as an academic pursuit grew out of "folklore" as an academic pursuit, and it has adopted some of the same positions of cultural and aesthetic relativ-

ism found among our folklorists and ethnomusicologists.

For a full understanding of, let us say, the genius of Charles Dickens it is important to recognize that he was a widely popular novelist, read by everyone from her ladyship to the cousin of her ladyship's cook. However, Dickens was either a great novelist or he was not. And in the final analysis, the standards by which that question is raised and responded to do not stand or fall on the nature of his audience. Shakespeare, we should understand, appealed to everyone from the notorious "groundlings" at the Globe Theatre, through ambitious young gallants, to members of the royal court or at least their siblings. But Shakespeare is either the greatest dramatist in the language or he is not. Verdi and Puccini wrote memorable operas or they did not. And Fred Astaire was either a great and boldly original dancer or he was not.

Gilbert Seldes often seemed to be telling us that we do better in our "lively" arts than we do in following closely European models. I hope I do not imply a full agreement with that position; I hope that I do not imply that praise for a Walt Kelly calls for disrespect for a John Singer Sargent. I would also invoke the wise insight of Ralph Ellison, in his essay "The Little Man at Chehaw Station" from *Going to the Territory,* on the range and diversity of culture shared by Americans of all backgrounds, classes, and interests.

Ellison is not a man to give much attention to the second rate. In the appreciative essays that follow in this book I hope that I do not single out the second rate for praise. I also hope that I give no over-praise here, that I do not imply that the United States has produced a Beethoven or a Shakespeare.

The essays do not intend to be a history or survey of the vernacular arts in the United States but only a discussion of some of our artists whose work seems to me exceptional or exemplary or especially interesting. And I do not suggest

that all of the genres that they represent are ours. We did not originate children's literature. And television technique is ours only in the ways that it has borrowed from cinema technique. In the essay on folk, my purpose is to raise some issues, not to praise. And particularly for musical theater and radio, I am concerned with what might best be done with that heritage, as well as with singling out examples of it for praise. Similarly the essay "Music on the Tube" is there to make some suggestions.

I cannot invite the reader to agree with all of my choices or my conclusions, I can hope that he or she will come away from these discussions feeling that we should no longer assume an inferiority for those American artists who have chosen to work in traditions that are our own—indeed for some of them, traditions they helped create.

Probably it will seem to some that I am ushering the barbarians up to the city walls and inviting the leadership to throw open the gates. Or that I am involved in some form of "deconstruction." But it seems to me that my standards are basically conservative, traditional, and those of Western humanism, at least I intend them to be. One recurring theme in the pages that follow is that the reputations of many of our vernacular artists suffer from the requisite prolific nature of many of those arts, and with the inevitably uneven quality of the overall body of work that results. But as John Kouwenhoven reminds us in *The Beer Can by the Highway,* "abundance is in a sense a product of waste." He adds, from Emerson, that "Nature makes fifty poor melons for one that is good . . . Nature works very hard, and only hits the white once in a million throws."

A new country needs a new culture; it cannot thrive on borrowed culture alone. We have produced a culture in this country which not only expresses our own lives but which the rest of the world finds irresistible. We live in a country which in recent memory has produced William Faulkner

and Dashiell Hammett; Martha Graham and Fred Astaire; Eugene O'Neill and John Ford; Frank Lloyd Wright and Walt Kelly; Charles Ives and Duke Ellington; Leontyne Price and Sarah Vaughan. And I am not sure, by the way, that Alexis de Tocqueville would have been quite sympathetic to any of them.

ON ASTAIRE

When Mikhail Baryshnikov defected in 1974, he granted several interviews in which he seemed to find the right moment to praise Fred Astaire. Baryshnikov's "he is great dancer" was perhaps the least of the many things he said in praise of Astaire the performer and Astaire the choreographer, and it would probably be no exaggeration to say that Baryshnikov considers Fred Astaire one of the great figures in twentieth-century dance.

Such recognition was not the first Astaire had received from other "classic" dancers, to be sure. George Balanchine had praised him often and had reputedly shocked his first American sponsors when he said that he too would like to work with Ginger Rogers. Merce Cunningham had praised Astaire. Jerome Robbins had praised him and had modeled some of his early work on him—or had tried to until he discovered that his classically trained dancers could not execute Astaire-inspired movements. But with our dance critics, and with the traditional guardians of our culture—

perhaps with most of us—the story seems a bit different. As a people, if we praise Astaire it is usually with the reservation that, yes, he was wonderful but surely his work was not in the class with "serious" dance, with truly artistic choreography.

What Fred Astaire accomplished is more significant than it may seem. When a Baryshnikov decides he wants to become a dancer, he goes to a teacher and he is told, well, yes, you must learn this movement and that one; and learn this and the other technique; and if you learn them all well enough you will be a dancer. And that means—let us be clear about this—you will learn to dance in the tradition of eighteenth-century French courtly dance, a highly stylized craft to say the least.

Astaire, in his totally unpretentious way, obviously did not want to dance like an eighteenth-century European. He undertook to dance like a twentieth-century American; he wanted to put our lives, our feelings, our experiences into dance. Who was to teach him how to do that? No one of course. He had to find out for himself what that meant, and that was a large and—if we admit it—culturally significant task. Astaire took the then-young traditions of American vaudeville and musical comedy dance in which he had grown up as his point of departure. And from bits of ballroom and ballroom-driven "specialty" dance, from black tap dancing, and (yes) some bits of classic ballet—from any sources that seemed appropriate to him—he fashioned his art.

Furthermore, Astaire had to learn what it meant to dance like an American named Fred Astaire, and there I think is where the truly democratic element entered. For an artist of his potential range and depth, learning to dance like Fred Astaire was, again, a sizable task. It was also a task which he clearly undertook with seriousness and discipline and with an unpretentious spirit of discovery and delight that always showed in the results.

If I could imitate Mikhail Baryshnikov I could have quite a career in classic ballet. Indeed, in classic ballet imitating Baryshnikov is in a sense what I would be asked to do. But if I could imitate Fred Astaire, I could probably have only a small career as a dancer. If Gene Kelly had based his work directly on Astaire's, it would have meant very little. Kelly, stocky, boyish, had to learn to dance like Kelly, and Kelly's elaborations of the hornpipe and the waltz clog, and his clownish acrobatics would have had as little place in Astaire's choreography as Astaire's elegantly romantic *pas de deux* might have had in Kelly's.

To draw a parallel for a moment, I have had the experience of playing a Sarah Vaughan record or two for opera aficionados and had them respond—once they were past their initial astonishment at her range and technique— "Why doesn't she study?" "Study what?" one may ask about a woman who had Vaughan's vocal resources and vocal discipline. But more seriously, vocal study would have meant that she would have learned to sing like a nineteenth-century Italian contralto. Sarah Vaughan wanted to sing like a mid-twentieth-century American contralto. She also had the privilege (and the responsibility) of discovering what it meant to sing like a twentieth-century American. And to sing like a twentieth-century American named Sarah Vaughan. And that meant, among other things, that she had the high privilege of turning almost any piece of music into an artistic experience.

Do I suggest that perhaps Americans ask of their performing artists that they have an individuality, that they exercise a self-discovery, even beyond that which Europe has traditionally asked only of her poets?

If Fred Astaire had been any less modest and a lot more pretentious about himself and his work—as pretentious, and as self-important let us say, as one or two of our "modern" dancers—he would have been written up regularly in our major newspapers and magazines as a great

American artist. Astaire simply became a great American artist not by announcing that he was one but by becoming one, and by leading and instructing his audiences, if not always his critics.

In making such comparisons and distinction as I make here, I hope I will not seem to be praising Astaire at the expense of classic ballet. A young country like ours partic- ularly needs the presence of ballet, not only for its intrinsic merit, but as a challenge and an example of the value and meaning of artistic stylization, discipline, and tradition. We also need the pioneering example of a Martha Graham, whose sheer theatricality might challenge any performer, and whose best dances have a mythic profundity unequaled in our drama, even in O'Neill.

I would have little to add in specific praise of Astaire's works to what Arlene Croce has to say in her splendid book, *The Fred Astaire and Ginger Rogers Book,* or to John Muel- ler's analyses and comments in his inspiring and compre- hensive *Astaire Dancing.* Croce's observation that Astaire and Rogers were "common clay" in no way contradicts Katharine Hepburn's perception that "he gives her class and she gives him sex appeal." Astaire had natural elegance. He was a democratic aristocrat, to use an apparent oxy- moron. Rogers, with her growing accomplishments as an actress, serious as well as comic, seemed more and more to play the grand lady. Astaire's innately modest yet confident nature was naturally elegant, and never seemed capable of putting on airs.

We are apt to think first of Astaire's great specialty solo dances, from the controlled virtuosity of, say, "Don't Let It Bother You" from *The Gay Divorcee* (1934) and "I Won't Dance" from *Roberta* (1935) through the drunken bar-room dance of "One for My Baby" from *The Sky's the Limit* (1943), and including the top-hat-and-tails masterpiece of "Puttin' on the Ritz" from *Blue Skies* (1946), and the ad lib chair and piano dance from *Let's Dance* (1950). But a

fascinating study might be done on the progression of Astaire's great romantic *pas de deux*, the seduction of "Night and Day" (*The Gay Divorcee*); the teasing, joyous, mutual self-discovery of "I'll Be Hard to Handle" (*Roberta*); the amorous awakening "Isn't This a Lovely Day?" (*Top Hat*, 1935); the poignant farewell of "Never Gonna Dance" (*Swing Time*, 1936); the guarded affection of "I'm Old Fashioned" (*You Were Never Lovelier*, 1942); and the beautiful falling-in-love of two former antagonists of "Dancing in the Dark" (*The Band Wagon*, 1953).

He was an unlikely romantic dancer, and an even more unlikely movie star, this man. Not only shy and modest, he was long of face almost to the point of being horse-faced. He was in his mid-thirties and balding when he made his first movie. He was loose limbed almost to the point of being gangly. He was thin and had large hands. No, not thin, Astaire was skinny, and his skinny frame was even used as a gag in the army induction scene in *You'll Never Get Rich* (1941). He was also graceful, elegant, and flexibly controlled. But Astaire in his greatness was made possible by the movies; he found himself and the true size of his talent when he entered Hollywood films. He discovered what he could do as a dancer and designer of dances, and what film could do with dance.

One hears rumbles nowadays that particularly in the early films, the dances are fine but the plots are silly and trivial. The plots are as standard as the scenarios of *commedia dell' arte*, of Plautus and Terence, as standard as the plots of Molière. And much as Molière's lines give the stuff of life to his plots, much as Shakespeare's lines and insights give life and depth to his borrowed plots and their characters, much as Verdi's and Puccini's music gives dimension and art to their plot lines and their sometimes banal *libretti*, so do Astaire's dances give life and depth to his films. It is through the dances that the stuff of character, conflict, and relationships is defined and made joyous and universal. And

it is through them that we learn that a light-hearted view of
the human condition can be a wise one, even a profound
one.

Croce, Arlene, *The Fred Astaire and Ginger Rogers Book* (New York:
 Outerbridge & Lazard, 1972).
Mueller, John, *Astaire Dancing* (New York: Alfred A. Knopf, 1985).
Except for *Blue Skies,* all of the Astaire films I mentioned—*The Gay
 Divorcee, Roberta, Top Hat, Swing Time, You Were Never Love-
 lier, You'll Never Get Rich, The Sky's the Limit, Let's Dance,* and
 The Band Wagon—are available on home video.

GRIFFITH
AND OTHERS

It would be nice to think that one could gather together the drama faculty of a major American university, propose a discussion of what the major American dramas are, and hear mention of, men like John Ford or Howard Hawks. Ford and Hawks were of course movie directors, but does not the motion picture account for some of the best drama to come out of the United States in this century? And should we not therefore honor two of its great figures as two of our major dramatists?

The name most likely to come up in such a discussion would of course be Eugene O'Neill, with perhaps some of the younger faculty suggesting Tennessee Williams. At his most pretentious O'Neill seemed to be asking himself, "How did the Greeks do this? That must be the best way to do it." One can imagine John Ford turning to his crew and asking, "Hey, fellas, how d'you think we ought to do this?" and then probably doing it the way he had intended to in the first place.

O'Neill's range as a playwright included the family
comedy of *Ah! Wilderness* through the family tragedy of *A
Long Day's Journey into Night.* It is interesting that he
wanted that latter play destroyed, which would have meant
that the tragic O'Neill would be remembered by the good
intentions of *Desire Under the Elms* (look what I found in
Sigmund Freud!), *Mourning Becomes Electra,* and his
middle-ground remembered by *The Iceman Cometh* (a long
evening's journey into platitudes for some of us, albeit an
interesting journey all the way.)* Howard Hawks's range,
on the other hand, seems almost unbelievable today, from
Scarface (1932), easily the most durable and mature of all
the "gangster cycle" movies; through the classic "screwball"
romantic comedies, *Twentieth Century* (1934), *Bringing Up
Baby* (1939), and *His Girl Friday* (1940); and including the
exceptional western *Red River* (1948). Even at his second
level, Hawks did the ironic war film, *The Road to Glory*
(1936); the comedy *Ball of Fire* (1941); the dark diversions of
To Have and Have Not (1944) (Hawks's down-to-earth
Casablanca, the Hemingway title notwithstanding); *The Big
Sleep* (1946); *Only Angels Have Wings* (1939) (Hawks's
variation on *Red Dust*); and *Rio Bravo* (1959) (Hawks's
response to *High Noon*).

John Ford's range was not so wide but his works
include *The Informer* (1935), *Stagecoach* (1939), *Young
Mister Lincoln* (1934), *My Darling Clementine* (1946), and
The Searchers (1956), and the moving and gratifying thing
about the work of this basically unreflecting man is the
absolute sureness, firmness, and basic humanity with
which he went about his tasks. From the beginning of his
career, from *Just Pals* (1920), say, Ford's screen fairly lights

* I do not mean to imply a criticism of O'Neill for turning to the Greeks. As
I have said above about the presence and vitality of classic ballet in our culture,
a young country and a young culture like ours particularly need a careful, even
reverential attention to Western artistic tradition, its disciplines and its accom-
plishments.

up with those qualities. And only once, ironically when he was working from O'Neill's material in *The Long Voyage Home* based on the early one-act plays, did his work seem a bit stage-bound.

One problem with our full acceptance of movies as central to our drama, one reason that we (sometimes unconsciously) place our film-makers aesthetically below our playwrights, has to do with the role of the movie director. We approach plays as a form of literature—rightly so, I think—wherein the playwright is the artist and the actors and directors are the craftspeople who bring things to life in performance. A play *can* have an existence as literature, aside from performance. In film, as observers of the motion picture art observed long ago, the director is central. Not that some good movie scripts are not eminently readable; I would be pleased to own a collection of (for one) Preston Sturges's best film scripts. And not that some highly skillful writers have not worked on films; in both *Twentieth Century* and *His Girl Friday,* Hawks was using the work of Ben Hecht and Charles MacArthur; in *Bringing Up Baby* he worked with the reputable Dudley Nichols; and in *To Have and Have Not* and *The Big Sleep* with William Faulkner. But Hawks regularly rewrote and improvised with his actors on the set. And one should never underestimate the crucial contributions of the cinematographer, of the film editor, of the highly skillful craftsmanship of good movie music. Still, the perspective of the director in film is central, and the early theorists of the movies were right. The camera intervenes between the actors and the audience; he who controls the camera and the resulting flow of images is the artist of the film. And a movie does not really exist until it is finished and projected on a screen.

It has even been said of the motion picture that, as the supremely cooperative form of theater, as an undertaking which depends on the work of so many people, which besides its director and its writers depends on the contribu-

tions of so many craftsmen and so many artisans, a film cannot be more than a kind of collective expression, a collective moral stand, something which is always in danger of becoming a kind of lowest-common-denominator cultural artifact. One response to that would be to point to the consistent, recognizable style, and thematic continuity of the works of the great movie directors. A second response would be to point out that the great Greek dramatists were all dealing with collective mythic material and working under strict religious controls as well. Yet the interpretive and aesthetic individuality of Aeschylus, Sophocles, and Euripides in those of their works that have come down to us is clear enough.

The role of the movie director often extends to the supervision of and collaboration with those who work with him, from script to final edit and scoring. Buster Keaton was rightly called in his lifetime "an American Molière," rightly because, particularly for that sublime half-decade between *Our Hospitality* (1923) and *The Cameraman* (1928), he was not only a great comic performer but the creator of a superb series of social comedies, as scripter (no matter with whom he may have collaborated), stager and director (no matter who may have been the nominal director), and star performer.

As a people, might we not better be encouraged to honor our great movie-makers, and not treat their works as a slightly inferior form of drama, or as cultural artifacts that reflect their times (all artistic pursuits, good or bad, inevitably do that)? And should not all Americans know that every device, every technique that is used to tell a story effectively on film is ours, that, in terms of artistry and technique, the motion picture is American? And that those techniques are the work of one man?

Film historian Richard Griffith said that "the origins of the older arts are lost in prehistory, their creators unknown or barely guessed." But for the movies "we have an almost

complete record of the birth of an art." James Agee has said that director D. W. Griffith was like "a great primitive poet, a man capable, as only a great primitive artist can be, of intuitively perceiving and perfecting the tremendous magical images that underlie the memory and imagination of entire peoples." And Lloyd Morris once said that Griffith's temperament made him treat the motion picture as an art and "the result was that he made it one."

Between 1908, when he first became a director for the Biograph Company, and 1913, when he left them, David Wark Griffith made more than four hundred short films—movies of from only eight to twenty minutes were then the norm. The earliest moving pictures were almost literally that, pictures with a static camera watching from a fair distance, as people moved around. Some early directors like Georges Meliès in France, Edwin S. Porter at Edison in New Jersey, and J. Stuart Blackston at Vitagraph in Brooklyn had shown ways of doing things differently. But particularly for Meliès and Blackston the emphasis had been largely on the level of a charming cinematic stunt work, and for Porter, a rather simple move away from incident and anecdote to narrative.

The story of the Griffith innovations, the film-by-film account of how he put the camera in the middle of things, how he composed shots with a painter's eye for visual weight and balance, how he built his story films shot by shot, angle by angle, with a musician's sense of rhythm and pace, has oftentimes been told. But it always seems to need telling again.

It all began rather modestly for Griffith: in 1908 he asked for a change of camera position in the middle of a scene in a little film titled *For the Love of Gold;* he wanted to get closer to his actors and their emotions, something virtually unheard of at the time. In the same year, in his first version of the Enoch Arden story, *After Many Years,* Griffith asked for a close-up of the leading actress's face to

show the audience her grief. Close-ups had been used before but usually as a stunt, as in the opening shot of Edwin S. Porter's *The Great Train Robbery* (1903), where an outlaw seems to be firing his guns into the camera, hence at the audience.

In *Edgar Allan Poe* the following year, Griffith used a window in one side of his set as his main source of light. An outdoor scene in *A Politician's Love Story* was shot directly in the early morning sun, awarding his actors halos. In *A Drunkard's Reformation* and *The Cricket on the Hearth* he used a fireplace as his source of light. By using a sliding panel over a light source he showed dawn breaking in a movie based on Robert Browning's *Pippa Passes* (1909).

In *The Lonely Villa* (1909) Griffith cross-cut shots of a mother and her two children trapped in their home by a pair of robbers with shots of the father rushing home. In *A Corner in Wheat* (1909), based on Frank Norris's *The Octopus,* he cross-cut shots of a tycoon celebrating a stock market victory with shots of a bread line in which his actors stand in a frustrated immobility, and he anticipated the "freeze frame," reputedly an innovation of the French *nouvelle vague* in the 1950s.

In *The Lonedale Operator* (1911) the actors are in the midst of an action as each shot begins, and in his climax Griffith cross-cut another rush-to-the-rescue with a newly heightened sense of cinematic rhythm. In reusing the same plot in *A Girl and Her Trust* (1912) he introduced the "tracking shot," showing a train's swiftly rolling wheels (he had his camera set up in an automobile moving parallel to the tracks). And by this time, Griffith had developed an almost uncanny ability to direct our attention to a single detail—a face, a stance, an object—even in a complex composition involving several performers.

Griffith was working carefully with his actors, ridding their work of many of the broad, flamboyant, gesticulating, histrionic mannerisms of the time, and the stage-bound

need to project all the way up to the second balcony. The camera, he understood, was only a few feet away, wherever the audience sat.

There is a climactic film from 1913 called *The Musketeers of Pig Alley,* a realistic, extraordinarily photographed film, vividly acted down to the smallest background part. It has been called, with justification, the first urban gangster film, but it might also stand as a perfect realization of all of Griffith's early innovations.

In all this, Griffith was drawing on and adapting the traditions of painting and its modern derivative, still photography. And of the short story and novel as well. By the seventeenth century the Academie Française had observed that painters made individual portraits, group portraits (or the more lively "conversation pieces"), scenes of daily life, landscapes and vistas. Griffith put all these points of observations and points of view to dramatic use and had them rendered with human figures in motion. They became the close-up, the two-shot, the group shot, the long-shot in the cinematic vocabulary. Then by editing he put them together with the right rhythm and pace to tell a story. And Griffith defended "all this jumping around" from shot to shot and place to place, of which his Biograph producers complained, by asking, "Doesn't Dickens write that way?"

A fascinating study might be done on the effect of Charles Dickens on American culture, although a great deal of it would have to center on the second- or even third-rate, to be sure. Horatio Alger spent his career writing and rewriting amalgams of *David Copperfield, Oliver Twist,* and *Great Expectations.* Harold Gray's "Little Orphan Annie" comic strip is clearly about a Dickensian hero in skirts having Dickensian adventures (Gray had originally conceived his character as a boy). Billy de Beck even made his Sunday strip, "Bunky," a wild parody of *Oliver Twist* and "Annie" combined. In Griffith, a Dickensian influence is central. Indeed, Griffith at his best saw the world through

the eyes of the child-woman who might have been Dickens's Little Nell, and who was perfectly rendered by his actress heroines like Lillian Gish and Blanche Sweet. Indeed, one can date Griffith's later artistic decline from the time when such a Victorian sensibility and view of the world no longer seemed meaningful.

When Griffith began to make full-length films, he gave us several that are exceptional, like *Hearts of the World* (1918), *Broken Blossoms* (1919), and *Orphans of the Storm* (1921). And he made some fine small films like *True Heart Susie* (1919) and *Isn't Life Wonderful* (1924). His undisputed masterpieces, however, *Birth of a Nation* (1915) and *Intolerance* (1916), are each a frustration. *Birth of a Nation* because its second half is, at best, embarrassing historically and morally as well as dramatically. *Intolerance* because its rapidity and complexity of structure made the film far ahead of its time, and the public's reaction (or lack of it) caused financial losses from which Griffith never really recovered.

Birth of a Nation, which tells of the Stoneman family of South Carolina before and during the Civil War and during Reconstruction, abounds with the sort of resonant images of which Agee wrote so eloquently. Its perfectly staged and edited battle scenes are both massive and intimate and show the personal bravery and military glory of war along with the horror of it, and Griffith's battles have been models for movie battles ever since. Its depiction of John Wilkes Booth jumping onto the Ford's Theatre stage after assassinating Lincoln looks not so much like a re-creation as like news footage that is somehow artistically heightened. *Birth of a Nation's* understated scenes of a Southern family hovering on a nearby hill as the Union army destroys their farmhouse below, or of the return of the Stoneman son to his now impoverished family after the war, are unforgettable. But to Griffith, Reconstruction in the South was a time of unjust humiliation for whites, certainly not a time for reflection and re-evaluation. His attitude toward blacks was that of a

patrician toward children at best, but beneath that, a matter of personal fear and destructive self-righteousness. Griffith challenged the holier-than-thou hypocrisy of the North and of many Abolitionists effectively, but in defending the South, he made blacks, and particularly mulattoes, his scapegoats. Worst and most frustrating of all, he ended his film with a stirring, brilliantly staged, timed, and edited ride-to-the-rescue. Innocent whites are saved by the Klan (a sympathetic Clan to Griffith). The whole sequence may rouse an audience, but it resolves nothing in his drama either dramatically or philosophically. (Still, if *Birth of a Nation* reflects racial attitudes which it has taken the South a century to begin to deal with, may we ask if the North has yet begun to deal with its hypocrisies on race?)

Intolerance parallels and ingeniously intercuts four separate stories. A contemporary tale of a young man wrongly arrested for murder and nearly executed includes stirring scenes of a labor strike and the troops that quell it, and the intimacy of a mother's grief at her son's arrest for murder. An ancient tale depicts the Feast of Belshazzar, the fall of Babylon, and the plots surrounding it, using massive sets and surging night battle scenes. A story of the St. Bartholomew massacre of the Huguenots in sixteenth-century France, with masterfully handled scenes of the French court. And a briefer, more stylized depiction of the crucifixion of Jesus.

Intolerance is still the biggest spectacle film ever made, and the later styles of the Russian, German, and Scandinavian cinema and Hollywood spectacle film can all be found in it. Its techniques of increasingly rapid cutting through time and space and from story to story, perhaps make it comprehensible and acceptable to movie audiences only today, despite the rank sentimentality of such things as a Babylonian subplot of the "Little Dear One." But it should be shown to modern audiences with the original colors and tints restored, red for fire and battle scenes, bright amber

for outdoor sunlight, blue for night scenes—every scene in a silent film used one tint, and Griffith, cross-cutting within a scene for dramatic effect, sometimes used more than one. And it should be shown with an orchestra playing its original score in accompaniment, the way that all important "silent" films were shown in their first runs.

The point with which I started—that we do not quite think of our best movies as major American drama—may seem strange in view of the fact that the Museum of Modern Art in New York has been collecting and showing movies since it was founded, and that Eastman House in Rochester and other museums have regular film showings; that film showings, film courses, and film societies abound on our college campuses; that the drama shelves of the average American bookstore are dominated by movie books; and that the American Film Institute exists and has official government sanction and support. But I raise again my somewhat rhetorical questions: Do we really think of Ford and Hawks (to confine myself still to those two names) as major American dramatists? Do we, as a people, really know and grasp the significance of D. W. Griffith's contribution to the arts?

There are many valuable books on the movies and their history of course, but among the critical studies of American films, I would name Walter Kerr's *The Silent Clowns* (Knopf, 1979) and James Harvey's *Romantic Comedy in Hollywood, from Lubitsch to Sturges* (Knopf, 1987).

My own book on Griffith is *D. W. Griffith: First Artist of the Movies* (Oxford University Press, 1980). Gerald Mast's *Howard Hawks, Storyteller* (Oxford University Press, 1980) covers the director's life and works.

Writing for Children

A RAG DOLL NAMED ANN

We can pretty well identify American literature. We know the names of our best poets and short-story writers and novelists and essayists, and their most outstanding works, with little disagreement or argument. But if I were to ask whether the United States has produced a respectable body of children's literature, and if so what its works might be, I would surely get puzzled and contradictory answers from most critics, scholars, and readers. From librarians I might get a recommended list that quickly moved to British, French, and Italian children's classics.

Children's books barely existed before the nineteenth century. During the twentieth century they have gradually divided themselves into four sub-categories which the trade

now calls "Under Five," "Five Through Seven," "Eight, Nine and Older," and "Young Adult." I raise that issue, however, only to admit that I am not quite sure into which of those categories the stories I am about to discuss would fit. I do know that they come from sources and writers that some will find unexpected, particularly for a country that has produced *Goodnight Moon, Where the Wild Things Are,* and *Charlotte's Web,* but I think that, like those books, they are worth serious attention and should have a much higher reputation than they have.

Raggedy Ann is surely one of the great American success stories. She is found everywhere, in greeting card shops, in toy shops, in variety stores, in bookstores. In the early 1970s there were some twenty of the original Raggedy Ann books still in print. However, when her creator, Johnny Gruelle, died in 1938 there were only two rather obscure obituaries. *

Johnny Gruelle was frankly a hack. Or to put it more kindly, he was a prolific author and illustrator. He turned out children's books and children's stories for popular magazines and newspapers; he drew comic strips and comic drawings at a great rate. He even illustrated an edition of the Grimm Brothers. It is a very handsome job by any standard, but we might remember that it was done by a self-taught artist.

If a man is as prolific as Gruelle, if he writes so many successful books and turns out other material as well, we are apt to view his work with suspicion: his writing couldn't be very good if there's that much of it. Then there is the mound of material turned out about Raggedy Ann since Gruelle's death, most of it credited to him but only a small part of it actually by him. Generally speaking, much of Gruelle's writing is not very good, but the best of Gruelle is

* In the *Indianapolis Star* for January 10, 1938, and the Norwalk (Conn.) *Hour* for the same date.

very good indeed, and unique, I believe, in children's literature, unique and quite American.

We might remind ourselves that some hacks write well. Daniel Defoe is of course a standard example in English of a hack whose best work is still read and cherished. In American writers for children, we have the example of L. Frank Baum, the man who wrote *The Wonderful Wizard of Oz*. Baum turned out an incredible amount of material under various pseudonyms, some male, some female, in addition to some fifteen books about Oz. We are only beginning to acknowledge that Baum, although he was no stylist, could be a very good writer, and that some of his lesser-known books are among the good ones: *The Patchwork Girl of Oz*, say, or *Tik Tok of Oz*, or, better still, a non-Oz book called *Queen Zixi of Ix*, which I sometimes think is his very best American children's story.

One problem with writers who are prolific, and whose work was not well evaluated in its time, is that a critic or scholar must read through a very large output in order to find the really good works. I do not mean to say that I have done something terribly difficult in reading all of Johnny Gruelle, but I have read a great deal of him, including all the Raggedy Ann books, and I have come to certain conclusions about him.

Johnny Gruelle (the family pronounced it Gru-ELLE), this very talented, very prolific man, seems to have been a born innocent; it would seem that he went through most of his life without a moral problem to his name. He was kind to everybody simply because it didn't occur to him to be any other way. And a kind of enviable moral innocence is both a virtue and a limitation in his writing.

His father, Richard B. Gruelle, was a painter, self-taught and well known in the Middle West for his landscapes. John was born in Arcalo, Illinois, in 1880 and raised in Indianapolis, and I think the American Middle West, its

language, and its ways are very much a part of the Raggedy Ann books.

Johnny Gruelle, his brother Justin, and his sister Prudence apparently had healthy, somewhat casual upbringings. Richard Gruelle seems to have let his children come and go pretty much as they wanted within reason, but they were all brought up with the idea of the importance of art with a little "a." If one drew and painted, one drew and painted and one was therefore an artist—whether what one drew or painted were editorial cartoons, comic strips, portraits of the wealthy, landscapes, or whatever. One simply did his best by what he had chosen to do.

Johnny became the staff illustrator for the *Indianapolis Star* while still in his teens, and a few years later for the *Cleveland Press*. He did every kind of drawing that a newspaper might require, weather cartoons, political cartoons, small filler drawings, illustrations for news stories for which there were no photographs, etc. He got through his work so fast and so well that he had time on his hands, and he used that time writing original children's tales and illustrating them. As it turned out, the editor liked these and began to publish them in the *Press*.

In 1910 Johnny went for a visit with his father, who had moved to Norwalk, Connecticut. While there, he entered a contest held by the New York *Herald* to see who could come up with the best idea for a new Sunday comics feature. Johnny Gruelle entered twice, under two different names, and he won the first prize and the second prize. That first prize went to the adventures of an imaginary little elf named Mr. Twee Deedle, and the feature appeared for several years in the *Herald* and the *Herald Tribune,* and was syndicated to other papers.

Johnny, married by then, moved his family to a town near Norwalk, called Silvermine, then a budding artists' colony. There he began turning out drawings for everything from *Physical Culture* magazine to humor magazines like

Judge, and writing and illustrating children's stories for *Good Housekeeping* and *Woman's World.*

Gruelle seems to have been a not-unusual combination of laziness and industry. Behind such a man there is often a driving woman, and Gruelle's wife, Myrtle, was apparently just that. There are stories about how she used to stop Johnny if he felt like going fishing or playing with the neighborhood children. She led him into his studio and reminded him, "You've got some drawing to finish for *Life* magazine," and while this man-child Johnny Gruelle drew, she would read him fairy tales.

The Gruelles had a daughter, Marcella, whom they dearly loved and who was their only child until their sons, Worth and John, were born. Marcella died unexpectedly when she was fourteen. The story goes that she had had a rag doll, Raggedy Ann, which had belonged to her Aunt Prudence. In memory of Marcella, Gruelle wrote and illustrated a series of stories about the doll, and Marcella's other dolls, short little tales of imaginary about-the-house adventures, and these became *Raggedy Ann Stories,* published in 1918. These were quite popular and there was a Johnny Gruelle Raggedy Ann book almost every year thereafter, and sometimes two a year, until 1937.

In the meantime, of course, the popularity of the Raggedy Ann books had meant other appearances of the character. Gruelle wrote Raggedy stories, with drawings, for newspaper syndication in the 1920s. There were Raggedy Ann dolls. And there was a single newspaper panel drawing plus a verse or a bit of cheerful advice each day in the mid-1930s for another newspaper syndicate.

In the middle 1930s, partly for reasons of health, and perhaps other reasons that I'm not aware of, Gruelle, Myrtle, and the two boys moved to Miami. There this innocent man seems to have met his first temptations, and, it seems, he succumbed to them, and gave up his former way of life. People who had known him in Silvermine said that

when he returned north for a visit they were shocked to find him overweight, puffy-eyed, and talking about being so busy attending cocktail parties that his work was suffering. Within a few years, Johnny Gruelle was dead, a combination it seems of his illness and the fast life he had begun to live in Florida.

The first group of *Raggedy Ann Stories* appeared in 1918 and is based on the idea, not a new one (it had been used in the rather grotesque "golliwog" tales of Bertha Upton, for one), that dolls have a secret existence and come to life when people are asleep or go out for an evening or away on a trip. The dolls walk and talk and have all kinds of adventures of their own. They find a puppy and adopt it and have to make arrangements for the puppy when "the real-for-sure folks," as Gruelle calls them, return. Or they have a picnic or a dance, or a wild pillow fight. Even with the real people around, Raggedy Ann falls in a bucket of paint and has to be scraped and washed, and have another face painted on. There the reader gets a double image of the way the real people are thinking about all this—particularly the way Marcella is thinking about it—and the way Raggedy Ann is thinking about it.

These first stories were followed by a collection of *Raggedy Andy Stories* in 1920, Raggedy Andy being, of course, Raggedy Ann's brother doll. One of the tales in this book I think is particularly charming. It tells how the dolls sneak down into the kitchen one evening while the real-for-sure people are away and have a wild taffy pull. There's a last-minute scrape when they have to get everything cleaned up and exactly in place, have to scamper up to the nursery and back into the same positions Marcella had left them in before the returning family comes through the front door.

Many of the stories in these early books are admittedly trivial, or so they seem to adults. But children love the idea of a secret life for the dolls, and they don't mind repetitious-

ness. There are two later collections of short, around-the-house Raggedy stories, *Beloved Belindy* and *Marcella Stories,* both from 1926. Belindy was a black "Mammy" doll of a kind that would never be written about today, but I don't think she is patronized. She is a nice, somewhat matriarchal being in the midst of the other dolls, who happens to be black. An incidental black servant in Gruelle's books might be somewhat patronized, but I don't think Belindy was.

To go back a bit, the 1924 Raggedy Ann book had been different, a book-length adventure called *Raggedy Ann and Andy and the Camel with the Wrinkled Knees.* (Long titles and long phrases like that one charmed Johnny Gruelle, and he used them a lot.) In this story, Gruelle took the Raggedys into his own version of fairyland, the Deep Deep Woods, just beyond Marcella's backyard. Gruelle's Deep Deep Woods seems a very American enchanted place, by which I mean it is an intriguing combination of European elements and ones that he made up using a very twentieth-century American imagination. There are witches but they aren't really very evil; they're mean maybe, but that's the worst you could say about them. And there are wizards and magicians, some of whom are a little mean, and some of whom put spells on you but they aren't really very bad spells. Sometimes they hide people from their parents or friends. That's about it, except that there is often a cheerful kind of humor and foolishness in what they do. Then there are princesses and princes. They are all very beautiful or handsome, or sometimes they're disguised as other people or other things and reveal themselves in the end. And there are kings, some of whom are grouches of course. Along with them there are little beings with names like Sniznoodle, Snarleyboodle, Little Weakie the Goblin, the Bollivar, the Snoopwiggie and his friend the Wiggiesnoop, and Mr. Hokus, who of course is a magician. And there are magic spells which can be broken by the answers to riddles like

"Why does a snickersnapper snap snickers?" The Deep Deep Woods is an innocent kind of fairyland, mostly full of niceness and kindliness and playfulness, and some naughtiness, but very interesting and often funny nevertheless.

There is one device that comes up often in these stories, one which is not untypical of children's stories of the time. Mud puddles may turn out to be made of chocolate ice cream. The enchanted fountains in the Deep Deep Woods may give chocolate sodas, and the bushes are apt to grow cookies or donuts. The symbolism is obvious enough, but we may be thankful that the device has now gone out of fashion.

In one early story, Raggedy Ann acquires a candy heart on which is written, "I love you" and it is sewn inside her. If she has "I love you" written on her heart, moral decisions probably come easy. Nevertheless, she can become a busybody on occasion. She finds out that owls eat mice and she doesn't like that, so she weans the owls over to cream puffs. Raggedy Ann has a wonderfully innocent idea of what's best for everybody else!

There are delightful small touches in the stories. In *Raggedy Ann in the Deep Deep Woods* (1930), the two dolls are wandering along, looking at the sights and saying hello to the animals, when they run into two old owls who live in a treetop, Mama Owl, who's old, and Papa Owl, who's also old and tired from having worked for years in a buttonhole factory.

As one reads these books, it may seem at first that Gruelle is just pouring out words and plot lines and incidents. And one may wonder: did Johnny Gruelle have a writing style? Did he have any sense of how to put words together gracefully? Or is he just pushing his incidents along? Is there some pattern or sense of organization in these tales? I think he did have a writing style, and I think it was very American, in its small way perhaps as American as Mark Twain's. The hint comes from those invented names,

the Snarleyboodle, and the Snoopwiggie, and Little Wea-
kie. That is the kind of word-making that little children
indulge in, making words and names out of bits and pieces of
the words and sounds they've heard adults use.

There are also the little repetitions. Hookey the Goblin
is always Hookey the Goblin. He's never the Goblin and he's
almost never Hookey. In *Raggedy Ann and Andy and the
Camel with the Wrinkled Knees,* there's the Tired Old Horse.
Sometimes he's the Old Tired Horse: sometimes the Tired
Horse and sometimes the Old Horse, but he is never, never
just the Horse. Or, elves and gnomes and fairies, or fairies
and gnomes and elves, or gnomes and elves and fairies, but
seldom two of the three, and never just one of them.
Children love this sort of elegant verbal ritual, and Gruelle
used that love in his books. Gruelle wrote his stories making
conscious literary use of the ways of children.

In *The Camel with the Wrinkled Knees* there are prin-
cesses and princes, and there is a Loony King, and there is a
witch, and there is the Old Tired Horse. But very soon we
meet a group of pirates who have a ship, a great big pirate
ship that navigates on the land. It has four wooden legs, you
see, which walk the ship along sort of like a great horse. The
pirates run around doing pirate things with the other people
and the dolls. But very early, Gruelle's charming drawings
begin to reveal something we might have suspected all
along. The big red nose on the leader is a false nose, and the
bandanna on the mean-looking pirate covers up the curls of
a little girl. Gruelle's drawings reveal that this assemblage is
really a group of Marcella's friends who are playing a pirate
game. We realize that the whole story is a game being played
by the children about the dolls, and that they are making it
up as they go along. As children, almost all of us, do. We
start making up a story and acting it out with a group of our
playmates. It rambles; it goes in this direction and that. It
goes in every direction you can think of until your mother
calls you for lunch.

Johnny Gruelle put these tales together with the same kind of casualness, the same kind of impromptu whimsy that children use in playing out a story-game among themselves. At the same time, he is aware of a good storyteller's need for selectivity and direction. He is the only children's writer I know of who consciously uses not an adult's way of talking to children but a child's way of talking and a child's way of making up stories.

Raggedy Ann and the Camel with the Wrinkled Knees is a very good book. *Raggedy Ann's Wishing Pebble* is also a very good book. (A magic wishing pebble is a wonderful thing. It is absolutely white and absolutely round, and if you find an absolutely white and absolutely round pebble, it will give you all the magic wishes you want.) As I say, a very good book, but the characters do spend some time in the opening pages sitting around a cookie bush and gorging on sodas and donuts.

Did Gruelle write a great children's book? I think he did in the one originally called *The Paper Dragon: A Raggedy Ann Adventure* in 1926 and republished in 1972 as *Raggedy Ann and the Paper Dragon*. It's about a little girl named Marggy whose father is lost. Well, he's sort of misplaced actually; it isn't a really bad situation; nobody is terribly anguished about the old boy; he's probably all right, you know, but since somebody's sort of misplaced him, we really ought to find him. There's a naughty magician involved, and there's Marggy and Marggy's mother and there are Raggedy Ann and Raggedy Andy, who are typically helping find Marggy's Daddy in the Deep Deep Woods. The dragon of the title is a very Oriental dragon until he gets a hole punched in his side and gets patched with a Sunday newspaper's comics section that is stuck on with some filling from a cream puff. That pretty well Americanizes him. He is hollow inside and at one point Mr. Doodle, the villain of the story, props his mouth open with a stick because he wants to use him for a chicken coop. That doesn't work very

well, it turns out, because if the chickens can run in easily, they can also run out easily.

The dragon is also full of dry leaves. It seems they blew in when he was yawning. Raggedy Andy gets put inside the dragon at one point, and wanders around for a while, and he can't find anything or anybody except those leaves. They also cause the dragon to cough from time to time, and eventually have him coughing out Raggedy Andy. Again, the book is that kind of rambling, charmingly meandering, humorous tale-spinning at which Gruelle could excel.

Raggedy Ann and the Paper Dragon also has good characterizations. Of course they are brief, almost blunt, as they are generally brief and blunt in children's books. Particularly in this book Raggedy Andy shines. He likes to get into boxing and wrestling bouts. They never amount to much, but he likes to box and wrestle, or anyway pretend that's what he's doing. The villains and the bad magicians are always irascible and do rather foolish things, like Mr. Doodle's propping open the dragon's mouth so that the chickens could get in, but also get out. At one point, a bad guy says something like, "If you want to find Marggy's Daddy, you must do something for me first. That's the way it always is in fairy tales."

Raggedy Ann protests, "But this isn't a fairy tale."

"Of course it's a fairy tale! How else could you two rag dolls be walking around and talking if it wasn't a fairy tale?" That's blunt and that's probably a child's direct way of looking at it.

There are other good Gruelle books. *Wooden Willie* is an exceptionally engaging quest story. It does not feature the Raggedys, however, but other dolls from Marcella's nursery, Uncle Clem the Scotch Doll and Beloved Belindy. Like many of the book-length adventures, *Wooden Willie* first appeared as a newspaper serial, and there its protagonists were Raggedy Ann and Andy, and since they are given stronger characterizations than Belindy and Clem, I wish

Wooden Willie had appeared that way in book form. (It still could actually. Even the pictures are there. Gruelle illustrated his stories for newspaper syndication, but did a completely new set of drawings for the book versions.)

There is one other story I would recommend. In the late 1960s and early 1970s, I worked on several Raggedy stories for their publisher of the time, Bobbs-Merrill, using surviving Gruelle material. One of these, *Raggedy Ann and Andy and the Kindly Ragman* (my suggested title was a more rhythmic *Raggedy Ann and the Kindly Rag Man*), came from a Deep Deep Woods adventure published in *Woman's World* in 1920 and written around two real-for-sure children, Jan and Jannette. It was largely a matter of my changing the protagonists' names and writing a few introductory and concluding words to get the real-for-sure people out of the house and the Raggedys off on their adventure and back again at the end. I would put *Raggedy Ann and the Kindly Rag Man* with *Raggedy Ann and the Camel with the Wrinkled Knees, Wooden Willie,* and *Raggedy Ann's Wishing Pebble,* and just below *The Paper Dragon,* as Gruelle's best children's stories.

I have said nothing about Gruelle's illustrations, but if you have ever seen his drawings, with their soft, curved lines, you have seen something special. If you want to know how good they are, pick up one of the books published soon after Johnny's death, illustrated by his brother Justin or his son Worth, and compare them.

As I say, I think that Johnny Gruelle's reputation would be much higher, and his books better known to our critics and scholars, if he had written less. Still, he wrote three or four very good children's books. He had his own way of engaging a child's mind and of using a child's outlook and a child's way with words. And I know of no other writer for children who did that.

THE CURIOUS CAREER OF PETER RABBIT

Surely Peter Rabbit is one of the most famous characters in children's literature. But there have been several Peter Rabbits, one British and three American. And at least two of those Peter Rabbits are still popular and still read, one of them British and one American.

It began of course with the remarkable British lady Beatrix Potter and with the little volume she called *The Tale of Peter Rabbit*. The story was originally written and illustrated for a young nephew of Miss Potter's and was privately printed in 1901. Three years later it was published in Britain by Frederick Warne, & Co. to national, then international, success.

Peter, as many a reader knows well, lives in the base of a tree with his mother and his siblings, Flopsy, Mopsy, and Cottontail. Peter's father is gone, eaten in a pie by the farmer Mr. McGregor, and Peter's mother has a hard time raising those bunnies alone. One day, as she is about to go out to do her shopping, she warns the bunnies to behave, and whatever they do, they should not go into Mr. McGregor's garden. So, of course, that is just what Peter does do.

Beatrix Potter had originally been a naturalist and had done some important work on symbiosis and on the germination of spores. But she had a hard time being taken seriously as a lady naturalist at the turn of the century, and with the publication of *Peter Rabbit* and its almost immediate success, Miss Potter became a successful writer and illustrator of books for small children, and she offered a succession of animal stories for the next several decades.

The Tale of Peter Rabbit was published in small, child-size format, with a sentence or so of text on each right-hand page and one of Miss Potter's charming watercolors on the left. And so were most of her other stories for children.

Three of Miss Potter's later stories were also about Peter Rabbit and his family and friends (and Peter is mentioned in passing in some of her other tales as well). There was *The Tale of Benjamin Bunny,* published in 1904, Beatrix Potter's fifth book. Benjamin is Peter's first cousin and he is even naughtier. He persuades Peter to take him into Mr. McGregor's garden so that Benjamin can see all the wonders to be found there that Peter had told him about, and to rescue Peter's little jacket and shoes, which he had left behind in his narrow escape under the fence.

In terms of basic plot, the first two tales are virtually the same. Peter and Benjamin almost get caught in Mr. McGregor's garden but manage to escape. This time, however, they escape because Benjamin's stern father appears outside the garden with a switch in his hand, directs their quick exit, and then uses the switch to punish them. Miss Potter's watercolor of old Mr. Benjamin Bunny is quite wonderful, with a pronounced Edwardian paunch under his vest and the proper air of severe patriarchal authority to go with it.

In *The Tale of the Flopsy Bunnies* (1909) it turns out that Benjamin Bunny grew up to be rather a ne'er-do-well who just couldn't seem to provide for his family or supervise his children properly, and like all rabbits, he had lots of children.

Since each of the sequels to Potter's original *Peter* seems to be decreasingly less well known, I will briefly recount the Flopsy Bunnies' adventure. Some of Benjamin's children get into a pile of refuse just outside Mr. McGregor's garden—it contained delicious, slightly rotting vegetables and cast-away weeds—and they gorge themselves. This feasting has a soporific effect and the Bunnies fall asleep. Along comes Mr. McGregor, who sees the succulent little rabbits, stuffs them in a sack, and takes them to his cottage kitchen to have his wife make a stew of them. The Bunnies, however, cleverly manage to cut their

way out of the sack from the inside and make their escape.

Thus in this tale, the Bunnies are caught by Mr. McGregor because of their carelessness or perhaps their gluttony; they do not enter his domain with the naughtiness and daring of Peter and Benjamin. Nevertheless, they also escape him through their cleverness.

Beatrix Potter's fourth Peter Rabbit book begins this way:

> I have made many books about well-behaved people. Now, for a change, I am going to make a story about two disagreeable people, Tommy Brock and Mr. Tod.
>
> Nobody could call Mr. Tod "nice." The rabbits could not bear him. They could smell him half a mile off! He was of a wandering habit and he had foxy whiskers; they never knew where he would be next.

The Tale of Mr. Tod was published in 1912, and it is a singular volume in the Beatrix Potter canon. It has more text than her earlier tales and is illustrated with rather harsh black-and-white drawings modeled on woodcuts. Mr. Tod is a fox and his friend Tommy Brock is a badger, but Beatrix Potter offers those identifications only through her drawings, not in her text. The book is not only about two disagreeable characters, it is also, I think, an unpleasant book.

I shall return to that latter point, but for now let me bring the Americans into this brief history. When *The Tale of Peter Rabbit* first appeared, it was not covered in this country by international copyright—the United States did not participate in such agreements then—and a Philadelphia publisher of children's books, Henry Altemus (the house had been one of Louisa May Alcott's publishers, by the way), offered a version that used Miss Potter's text and her illustrations traced to simple line drawings with colors inexpensively added on. This Altemus edition proved so popular that the publisher generated a series of sequels,

mostly credited to Linda Stevens Almond and May Wynne, and bearing such titles as *How Peter Rabbit Went to Sea, Peter Rabbit Went A-Fishing, Peter Rabbit and the Big Brown Bear, Peter Rabbit Went to School, Peter Rabbit's Wedding Day*, etc. At least eighteen of these little books were published, and some of them could still be found in bookstores in the 1930s. There seems to me no reason to discuss them further, however. They are poorly conceived and written, and seem to me virtually unreadable.

Much better is our next American Peter Rabbit, the Peter of Thornton W. Burgess. To most people, his is as well known as Beatrix Potter's Peter; to some Americans, better known. Burgess was a journalist who began his anthropomorphic tale-spinning when his wife died and he began making up animal stories for his small son at bedtime. A rabbit he called Peter began to be featured in many of them. Burgess submitted some of these stories to *Good Housekeeping* (it was a rather different magazine in those days), where they were published. Eventually Burgess's stories were taken on by a small newspaper syndicate and then by the larger syndicate of the New York *Herald-Tribune*. For over fifty years Burgess wrote a "Bedtime Story," as they were headed, every day, six days a week. They were not all about Peter Rabbit, to be sure, but many of them were. They were collected in a series of books published by Little, Brown & Co., beginning with *Old Mother West Wind and Her Children* in 1910, and many of the Burgess collections are still in print.

Burgess's original illustrator, both for the daily stories and the book collections, was a cartoonist named Harrison Cady, a gifted man with a singular style who had contributed his flat, poster-like animal drawings to *St. Nicholas* magazine and other publications before he became associated with Burgess. Cady himself was soon providing a weekly Sunday comics page called "Peter Rabbit" for the *Herald-Tribune* syndicate, in a weekend counterpart to the

daily "Bedtime Stories." In Cady's version, Peter's wife and two naughty sons ("pesky," Peter usually called them) are featured in fairly predictable conflicts and scrapes.

About his appropriation of the name Peter Rabbit, Thornton Burgess said in his autobiography:

> Beatrix Potter of England named Peter Rabbit when she found him in Mr. McGregor's garden. With fascinating text and talented brush she made a classic of the event in the delightful little volume children everywhere know and love. I believe they always will. When I began writing my stories for my own small boy, a rabbit was already Peter and there was no changing the name.

Burgess adds that he would like to think that he, with Cady's help, made Peter into a character. That is perhaps a curious and immodest thing for him to say, but it will direct us to some comparisons on the differences between his Peter and Miss Potter's. I should point out that Burgess also borrowed some trappings from the Br'er Rabbit stories of Joel Chandler Harris as well—a fondness for escaping into the "good old briar patch," for one.

When Burgess's Peter Rabbit got his own first book collection of stories in 1914, he didn't quite get the book's title. Burgess wrote a brief opening story in which he had Peter decide that "Peter Rabbit" was a very ordinary name, and so was the name "Br'er Rabbit," and he wanted his name changed to Peter Cottontail, and the book was titled *The Adventures of Peter Cottontail*. But after that first, rather dull story, Peter became Peter Rabbit again, and the whole question of his name change was forgotten.

In Beatrix Potter's stories, through an integrated combination of pictures and text, one gains a feel of the English countryside and its fauna. And, although her animals are given human motivations, they also behave instinctively like animals, going where small animals go, doing what they do,

eating what they eat. On their human side, they have recognizable attitudes—Peter's mother warns him of danger, Benjamin's father rescues and punishes his son and nephew. Through these, and the actions of Mr. McGregor, readers old and young alike are instructed about people. And whereas we recognize the disobedient naughtiness of Peter, and we feel his danger and his fear, we still sympathize with his curiosity and of course admire his daring.

Throughout her first three little escape melodramas, Miss Potter seems to accept nature and human nature. Mr. McGregor is not depicted as bad or evil for wanting to eat a rabbit pie. (Who wouldn't want one? They are delicious.) The cat who nearly catches Peter and Benjamin is not wrong to chase them; she is simply being a cat. Rabbits have their nature and their sources of food; cats have theirs; humans have theirs. Conflicts result. Conflicts are a part of life.

Still, there is a strong temptation for writers of children's stories to turn animals into rogues and villains simply for being their instinctive selves, and a few very good children's writers have succumbed to it. Beatrix Potter resisted that temptation until *The Tale of Mr. Tod*. There, unexpectedly, a fox is wrong to behave like a fox. For being cunning, for being carnivorous, for catching Peter and Benjamin, and for smelling like a fox, Mr. Tod is "unpleasant" at best, evil at worst. And Tommy Brock is at best "not nice" because he ate wasps, frogs, worms, and "waddled about by moonlight, digging things up"—in short, because he behaved like a badger.

The most frequent antagonist of Burgess's Peter was Reddy Fox; another was Shadow the Weasel. One is encouraged to feel a certain satisfaction when Peter outwits either of them, but they are nevertheless a fox and a weasel doing what foxes and weasels do.

Burgess's best Peter Rabbit tales involve chases, but they do not involve suspenseful captures like the one the

Flopsy Bunnies experience. And there is a fundamental element in them that would be out of place in Miss Potter's world: Burgess made his best tales out of physical low comedy, out of knockabout farce.

In "Reddy Fox Gets a Scare," one of the stories in *The Adventures of Peter Cottontail*, Peter enters the garden of Farmer Brown on a bright moonlit night. (Farmer Brown is the Burgess counterpart to Mr. McGregor.) Peter is after some succulent young cabbages he has seen growing there, but the moon is bright and the night cannot protect him from Reddy, who soon arrives. Luckily, Peter sees Reddy before Reddy sees him, and he quickly hides himself under a large straw hat which Farmer Brown's son had left in the cabbage patch. Peeking out, Peter raises the hat a trifle and quickly lowers it again. Peeking out cautiously again, Peter sees that Reddy is staring at the hat and looking frightened and realizes that Reddy has seen the mysteriously moving hat. He hops the hat quickly along three times. Reddy flees for his life. Peter rolls over with laughter.

A comparable sort of incident might be found in a turn-of-the-century Viennese or French farce, in a 1920s American silent film comedy, in a burlesque sketch, or in a contemporary TV show. A husband, nearly caught by his wife in an apparently compromising position, hides under a small restaurant table which he gradually moves towards a door. Or he hides behind a department store dummy which he inches along towards an exit.

In another of Burgess's better stories, "Shadow the Weasel," Peter is chased by Shadow and leads him into some bushes which cover a small water pond. As Shadow comes toward him, Peter jumps across the pond. The short-legged Shadow has to run around the pond, and when he does, Peter simply jumps back across. Shadow runs around again, Peter jumps across again. Etc. Shadow, finally exasperated, loses his presence of mind, tries to jump the pond, falls in, and as he thrashes around in the water, Peter

makes his escape. Again, some good farce comedy with a farce ending, but not quite unbelievably beyond the natural actions of a rabbit and a weasel. Burgess saw himself in his autobiography as a self-educated naturalist, but the action of his stories often includes knockabout as old as comic theater itself.

Thornton Burgess, like a number of extremely prolific American writers, wrote so much that one would not expect much of it to be very good. The best of it, however, is well worth our attention. Perhaps we could look forward to a small volume of select Burgess tales (the early ones must be in the public domain by now), collected for small children. Harrison Cady's enhancing drawings should all be restored to their rightful places, and others could be borrowed and interpolated, for many would fit. And selective Burgess, with his love of cleverness and spunk and his relish of simple physical action, will not only continue to delight small children, he may continue to hold a mirror of low comedy up to all of us.

All of the original Raggedy Ann books I have mentioned are now out of
 print. The current (1987) *Raggedy Ann and Andy and the Magic
 Wishing Pebble* is a shorter re-writing by Cathy East Dubowski of
 Gruelle's *Raggedy Ann's Wishing Pebble*.
The two Burgess stories I have discussed are included in *The Adventures
 of Peter Cottontail* (1914).

ELLINGTON AS A MAJOR COMPOSER

To most people, Duke Ellington was an American dance band leader who also wrote a number of familiar popular songs which are in the repertories of most cocktail pianists and saloon singers. He was that, but he was much more than that. Indeed, he was something besides that.

Were we to list Ellington's works by more traditional categories, we would say that he was an American composer who wrote popular songs; who wrote theater music; who wrote works for solo piano and for piano and bass duo; who wrote works for small jazz ensemble, usually a septet; who wrote, alone or collaboratively, instrumental miniatures for jazz orchestra (literally thousands of them); who wrote film scores; who wrote ballet music; who wrote extended works for jazz orchestra, usually in one or another version of suite form; who wrote works for jazz orchestra and symphony orchestra combined; and who, toward the end of his life, wrote liturgical works which he called concerts of sacred music.

My proposition (which is certainly not mine alone) is

that Ellington was a major American composer, and in some respects *the* major American composer. Billy Strayhorn, who was from 1940 until his death in 1967 the orchestra's co-composer and a frequent collaborator with the leader, once said that although Ellington played piano, his real instrument was his orchestra. And, like Josef Haydn, Ellington had the privilege of having his own orchestra to play whatever he wrote as soon as he had written it. Indeed, to anyone familiar with the way Ellington worked, the orchestra and its members guided him as a composer and, particularly in his early career, showed him the kind of music he was to make. Soon he was working with them in the same way that the great Greek and Elizabethan drama-tists worked with the individual talents and resources of their actors, and the great choreographers with the specific abilities and the possibilities of their dancers. I pick these analogies partly as a response to those who say that Ellington's music, being so personally conceived, cannot be played by others. We still perform *Oedipus Rex, Hamlet,* and *Candida.* We still dance *Swan Lake, Giselle,* and *Les Sylphides.* We still perform the "Goldberg" Variations and Haydn's Sixth, Seventh, and Eighth symphonies. Ellington seems to have known what his players could do sometimes before they knew, and recordings repeatedly show us that many of his musicians, who did well before they joined him and well after they left him, did brilliantly and grew markedly so long as they were with him.

The turning point in Ellington's career, and his real awakening as a musician, came in December 1927 with a three-year engagement at the then-new Cotton Club in Harlem. There the nightly one-hour revues required him to provide overtures; accompaniments for chorus dances and for specialty dances; music for choreographed parades by "show girls"; music to get comedians on and off the stage; music for sketches both comic and dramatic; accompani-

ments for a featured singer; and showcase instrumentals for the orchestra, in addition to providing dance music for the club's patrons before and between the shows. Ellington had to turn his dance band into a theater orchestra. He was soon fulfilling that role with brilliance and originality.

In discussing Ellington the composer, of course I do not mean only Ellington the tune writer or songwriter, but Ellington the writer of music for his orchestra. To put it another way, it makes about as much sense to re-orchestrate Ellington as it would to re-orchestrate Ravel or Stravinsky, and for precisely the same reasons.

Basic requirements for greatness in music of course include originality and uniqueness. I doubt if anyone even mildly acquainted with Ellington would doubt that his orchestra had an identifiable *style,* but making my claims for him I am speaking of qualities somewhat deeper and more important than style.

In thinking about how I might defend such a claim for Ellington—defend it perhaps against accusations that it is foolish or naive—I asked myself how I might defend such a claim for a Haydn or a Brahms, and it seemed to me that I would undertake it by isolating certain basic musical elements and making certain demands on them.

The element of music that is the most obvious to most people is of course melody. What kind of melodist was Ellington? As I have already acknowledged there are several dozen familiar tunes that are his or his collaboratively with members of the orchestra. As one always needs to point out when talking about Ellington's themes, most of those which became popular songs were originally conceived instrumentally and were made into popular songs by having lyrics added (alas, often poorly written lyrics), and sometimes this involved changing or simplifying their original melodic lines.

Avoiding familiar themes, I could cite such things as "A Hymn of Sorrow" from the 1935 short film suite *Symphony in Black*. Or the third, "interlude," theme for open, unmuted trumpet in the "Concerto for Cootie," Ellington's 1940 masterpiece for his trumpeter Charles "Cootie" Williams. Or "Single Petal of a Rose" for piano and bass from the *Queen's Suite*, written for Elizabeth II in 1959. These seem to me outstanding melodies.

Among Ellington's instrumental works, there are, by the way, several intriguing melodic lines that move in slow motion, with whole and half notes dominating. Sometimes these can be memorable, like the opening section to "Mood Indigo" (1930) or the "Almost Cried" theme from Ellington's music for the 1959 film *Anatomy of a Murder*. Others, like the openings to "Blue Light" (1938) or "Subtle Lament" (1939) or "Ko-Ko" (1940) seem intended only to set up musical textures and moods to enhance the work of the soloists that follow them.

Obviously, to decide what kind of melodist Duke Ellington was one would have to sift through hundreds of his themes. My own tentative conclusion, after years of living with his music, is that Ellington was not a great melodist, although he did compose some great melodies. Still, it is worth remembering that if standards of melody in the European concert tradition are set by Mozart and Schubert, say, then Beethoven was not necessarily a great melodist. The case for musical greatness does not stand or fall on melody alone.

Nowhere did Ellington excel more, nowhere did his musical discernment show itself more than in his discovery and use of the individual instrumental techniques and sounds of his players. It has been said that Ellington knew intimately the sound and timbre of every note of every player in his orchestra. The most typical sound was of course

of plunger-muted brass, initially James "Bubber" Miley's trumpet, with its musical passions produced by manipulating the rubber end of a plumber's suction plunger over the instrument's bell. The technique was also used by Joe Nanton, the orchestra's seminal trombonist, and it became a permanent resource in Ellington's orchestra. Miley's successor, Cootie Williams, extended the plunger discipline with remarkable flexibility and range of timbres, and he developed the use of the plunger over the short, "pixie" straight mute for still another range of sounds. Ellington also used the "half-valve" techniques of cornetist Rex Stewart in everything from the humorous "Boy Meets Horn," and the joyous "Emancipation Celebration," through the ravishingly plaintive solo on "Dusk." A later Ellington trumpeter, Clark Terry, used half-valves, the plunger, a personal array of lip and tongue techniques, and a sophisticated chromaticism in his choice of notes, at a level of high virtuosity and, where appropriate, a delightfully spirited sense of humor.

There is a grand moment in the 1938 treatment of "Black and Tan Fantasy" when clarinetist Barney Bigard's ability at circular breathing has him executing a beautifully controlled *glissando* which rises from a high D flat through a high F, for almost a full twelve-bar blues chorus at slow tempo. And to jump ahead of my discourse for a moment, along with Bigard's rising sound, there are simultaneous textures from Ellington's keyboard in middle range and Joe Nanton's plunger-muted trombone below.

Almost any listener will respond to the way that Ellington combined the instruments and their sonorities. The standard "big band" jazz style involved antiphonal, call-and-response textures with the reeds doing one thing, the trumpets responding, the trombones commenting. Or a statement by the full brass with the reeds responding. *Et cetera.* But, Ellington might cut across his sections and use

two of his saxophones, one trombone, and two muted trumpets for a statement that is responded to by his clarinetist complemented by his own keyboard.

In celebrating Ellington's harmonic language, André Previn once said that any Hollywood composer could be given a commission, a large orchestra, and a premier concert, and every other Hollywood composer in the house could explain exactly how he achieved every effect in his piece. But Duke sits at the piano, lifts one finger, three horns make a sound "and I don't know what it is."

In his harmonic voicings, in his ways of putting notes together unexpectedly, Ellington excelled. A celebrated early example is the first chorus to "The Mystery Song" (1931), which still baffles most of us as to which horns, with which mutes, have what notes in the compelling musical texture.* From among the hundreds of other possible passages in the Ellington canon, Gunther Schuller has particularly drawn our attention to the voicing in three pieces from the late 1930s.

"Blue Light" (1938) is one of a series of pieces in which Ellington explored what came to be called "the 'Mood Indigo' effect." The opening theme of "Mood Indigo" (1931) was scored for muted trumpet, muted trombone, and lower-register clarinet. (Any standard guide to orchestration would of course have explained that the clarinet should be used for its upper register, for its notes not covered by the other brass and reed instruments.) Ellington returned to the trumpet-trombone-clarinet idea many times, not to repeat a success but to explore the sonorous and harmonic

*My guess is that the passage also involves a creative use of the early electrical recording process in that some of the players are facing away from the microphone.

possibilities further. In "Blue Light," Ellington is melding
notes from the blue scale into his voicings:

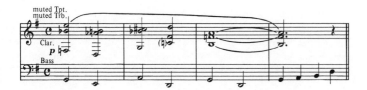

(I am borrowing the notations here from Schuller from his
book *Musings*. I hope readers unfamiliar with music nota-
tion will not be put off by them. Those who do know
notation also know that there is no substitute for hearing
music.)

From the year following, there is "Subtle Lament,"
also in blues form. (I am convinced, by the way, that Joe
Nanton's plunger-muted trombone is doubling one of the
lines here.)

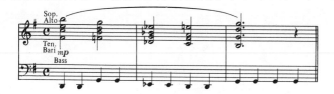

Schuller also cites the final chorus of "Azure" (1937),
particularly the following strikingly original passages:

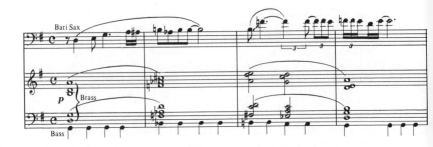

and this:

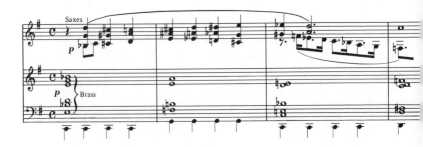

A detailed study of the evolution of Ellington's har-
monic language might turn out to be one of the most
valuable scholarly resources in American music, not only
for his own reputation but for the enlightenment of future
generations of composers as well. It may be that there is
precedent for everything he did harmonically in, let us say,
the works of Bartók and Stravinsky, but Ellington discov-
ered these things for himself, and the evolution of his
harmonic style and the contexts and patterns with which he
used his ideas are his own. And I suspect that whoever did a
study of his voicing might discover that Ellington developed

his harmonic vocabulary using simple triads plus the blues scale as his point of departure.

Ellington did not work out such things in the abstract; it was not a matter of this note plus that note plus the other. It was again often a matter of his response to his musicians. This man has a really interesting timbre to his upper register D; how it would sound with that man's strong F sharp. Or it was a matter of knowing that Harry Carney, the orchestra's baritone saxophonist, could do sustained circular breathing with marvelous control, so suppose he held a middle register G flat as the other saxophones moved from note to note legato.

The question of Ellington and rhythm, like the question of Ellington the melodist, might occupy us at some length. My own general conclusion is that Ellington made a personal use of the common rhythmic language of the jazz idiom as it evolved from the mid-1920s through the 1970s (but he made little direct use of the rhythmic language of the mid-1940s be-bop style). There are some exceptions, however, and perhaps the most effective of all, as I am grateful to Doug Richards for pointing out, is "Madness in Great Ones," his musical portrait of Hamlet from the 1957 suite based on Shakespeare characters, *Such Sweet Thunder*. Here, Ellington picked his materials impeccably. The melodic and rhythmic motives, the sonorities and voicing, are perfectly chosen to present us with a relatively happy-go-lucky college student who is confronted with a horrifying situation and with responsibilities and temptations that soon bring him near madness.

The isolation of any of the basic elements of music, as though it could exist and be evaluated alone, is a necessary step in analysis but ultimately a delusion of course. Nowhere is that more obvious than in a discussion of musical

texture. Almost everything in musical performance may be said to involve texture of some kind but Ellington produced some striking examples. Again using Schuller's notation, there is the remarkable, and remarkably fast, "hocket" passage in "Braggin' in Brass" (1938) for the orchestra's three trombonists:

Each man in succession has a note in a continuous melodic line, but a different note each time to make it more challenging. The passage is almost perfectly executed by the earthy Joe Nanton, the virtuoso Lawrence Brown, and the valve trombonist Juan Tizol, and it would be impossible to say for sure which man has which notes. Their solo voices however were otherwise so different that they might almost be playing different instruments. And, as with Barney Bigard's held note on "Black and Tan Fantasy," in context the passage is no musical stunt but a dazzlingly effective part of a virtuoso instrumental work.

The septet "Where's the Music" is one Ellington masterpiece we are extremely lucky to have. Conceived for Clark Terry's trumpet, John Sanders's valve trombone, Johnny Hodges's alto saxophone, Jimmy Hamilton's clarinet, Jimmy Wood's string bass, Sam Woodyard's drums, and the leader's piano, it was recorded in 1957 but not issued until 1985. Particularly because of its sparse instru-

mentation perhaps, this lovely blues lament clearly illustrates all the elements we have discussed, in its memorably simple melodies, its striking sonorities, densities, and voicings, in its perfectly placed and integrated polyphonic layers—including improvised antiphonal responses by Terry and Hamilton—and its perfect overall contours of rise and fall.

One might present the case for Ellington's excellence solely on the basis of his instrumental miniatures for his orchestra. But what of his longer works? It has been said that they are simply collections of short pieces, often put together with only a basic regard for contrasts of key, tempo, and mood; that they are collections of Ellington miniatures, and are sometimes uneven collections.

Admittedly that is true for some of them, but there are wonderful exceptions. For one, *Reminiscing in Tempo* from 1935, Ellington's second extended work. *Reminiscing in Tempo* is integrated throughout its four sections; it states, develops, and echoes its three main motives (two, some would have it) plus secondary motives, without heavy dependency on simple additive form, and it shows a control of textures, densities, and dynamics that were unique in his work.

Similarly, there is the collaborative *Suite Thursday* (1960) by Ellington and Strayhorn, a wonderfully light-hearted work written after John Steinbeck's casual novel *Sweet Thursday*. Each of its four parts is in blues form, with Ellington using the twelve-measure version in his first and last sections, and Strayhorn using ingeniously expanded and contracted versions of the briefer eight-bar blues in the two middle sections. The whole piece is built around the simplest of motives, a descending minor sixth, A-flat to C, first stated by Lawrence Brown's trombone. The motive weaves in and out, becomes the opening notes of one melody here, the closing notes of another there. It makes its final

appearance in a delightful, improvised coda for Ray Nance's violin, in which he casually pretends to lose the motive, then searches for it and triumphantly finds it again.

I am not sure that any but the most expert dancers would want to get up and move around the floor to such things as "Braggin' in Brass" or "Daybreak Express" (1933), but many of Ellington's greatest pieces functioned as dance music, within the conventions of music for the social dances of their time. And therein lies probably the greatest difficulty for some of us in acknowledging his stature. Take "Dusk" (1940). At one level it is a big band dance piece of its time, recognizably so by almost anyone. A more musically aware listener will be struck by its exceptional orchestrational skills and admire them. The difficulty comes in the next step, for at its highest level "Dusk," like many another Ellington piece, is a finely conceived short tone-poem for orchestra.

In his 1941 book *A Guide to Recorded Music*, Irving Kolodin said that the term "serious music" is not an estimate of the end product but a description of the artistic intent and the technical integrity with which it was composed. "I may clarify this," he added, "by saying that I consider all of Johann Strauss serious music, and very little of Lehar or Oscar Strauss." Ellington's intentions were serious and his techniques were his own. So were his accomplishments.

Gunther Schuller's essay "Ellington in the Pantheon" is included in *Musings* (Oxford University Press, 1986), and there are detailed examinations of Ellington's career in Schuller's *Early Jazz* (Oxford University Press, 1968) and *The Swing Era* (Oxford University Press, 1989). Some of my own thoughts on Ellington are in *The Jazz Tradition* (Oxford University Press, 1983). A complete

performance of *Symphony in Black*, conducted by Schuller, is available on Smithsonian 1024. *The Queen's Suite* is on Pablo 2310–762. "Boy Meets Horn" is on *Ellington 1938*, Smithsonian 2003. *Such Sweet Thunder* is Columbia JCL1033. Most of the other works I have discussed here can be heard in a four-CD series on GM Records 3019cd–3022cd, *Duke Ellington: Seventy Masterpieces, 1926–1968*.

THE GREAT AMERICAN MUSICAL

On March 31, 1943, a singer-actor, eventually revealed as dressed in a cowboy outfit, began a new Broadway musical by the offstage singing of a Neapolitan-style waltz. The reviews the next day were strongly favorable and Broadway journalists were soon announcing that a "real" American musical theater piece had finally arrived. Six years earlier, a singer-actor dressed in a Roman toga had offered the playful syncopations and sassy lyrics of "This Can't Be Love," and one may be entitled to wonder what could have been more American than that.

The first show in question is of course Richard Rodgers and Oscar Hammerstein II's *Oklahoma!*, and the song in question is "Oh! What a Beautiful Morning." The second is Richard Rodgers and Lorenz Hart's *The Boys from Syracuse*, a musical treatment of Shakespeare's *Comedy of Errors*.

Some elaborate claims have been made for *Oklahoma!* and its successor shows from Rodgers and Hammerstein— *Carousel, South Pacific, The King and I*, etc.—and it seemed

that Brooks Atkinson, theater reviewer, of the *New York Times* spent a great deal of his time in the 1950s making those claims in his reviews of musicals, in Sunday drama section "think" pieces, and in articles in the Sunday *Times* magazine.

It was said that for the first time in an American musical, the songs moved the plot along, expressed situation and conflict, and revealed character. The dances, too, were similarly integrated. And *Oklahoma!*'s set-piece ballet designed by Agnes de Mille paralleled the dramatic action and further revealed the inner conflicts of the heroine. In earlier American musicals, the claims continued, the drama had stopped dead for a song to be sung or a dance to be danced, or the introductions of the songs and dances were contrived affairs, and they were mostly irrelevant (or at best peripheral) to the drama or the comedy. The plots themselves, it was said, were casual fluff and mainly an excuse to string some good songs together. To express his enthusiasm for the Rodgers and Hammerstein musicals and their progeny, Atkinson began to call them "music dramas" (surely a Wagnerian should have cautioned him that the term had been used before, and somewhat differently).

As I read these things in the 1950s I could not imagine that anyone who had seen Fred Astaire–Ginger Rogers musical films could be writing them. Aside from an occasional "on stage" sequence, or a very rare "production number," there is barely a song in those films that does not express the state of Fred and Ginger's relationship, barely a dance movement that does not reveal character and heighten conflict. Indeed, it was Rogers's *forte,* as a questionable singer and a graceful but far-from-expert dancer, that she *acted* those songs and dances so perfectly. Subsequently I have learned that earlier Broadway musicals themselves were not nearly so guilty of the sins ascribed to them. Indeed, it may be said of them that their only sin is that they are not so self-conscious and do not take them-

selves as seriously as *Oklahoma!* and *South Pacific* do.

I am not saying that I find *Oklahoma!* and *The King and I* poor examples of musical theater. I admit to strong reservations about *South Pacific,* however, which seems to me a prettified and self-serving picture of American service men, race relations, and all the other issues it raises so earnestly. My real question, however, is just how American *Oklahoma!* is. And the answer, in terms of its music and dance, is not very.

The music: Broadway song-writing largely derives from Vienna and its operettas, its song forms and its attitudes, with some glances at Gilbert and Sullivan. Victor Herbert, a superb melodist and orchestrator, Rudolph Friml, and Sigmund Romberg imported that Viennese sensibility. Jerome Kern's songs were less Viennese, and those of Berlin, Gershwin, and their successors less Viennese still, because they borrowed from ragtime and jazz: rhythms, syncopations, "blue notes," but their forms were still largely operetta forms.

The young Richard Rodgers, the brash composer who worked with Lorenz Hart, borrowed from jazz left and right, but under the surface his inspiration lay with Kern, and when Richard Rodgers began to work with Oscar Hammerstein II, he rediscovered that inspiration. Indeed, in the songs in *Oklahoma!,* Rodgers not only shows much less jazz influence than he had in *Pal Joey* or *The Boys from Syracuse,* he uses fewer idiomatic Americanisms even than Kern. There may be a hint of ragtime in "Everything's Up to Date in Kansas City" from *Oklahoma!,* but only a hint.

The dances: In her *Oklahoma!* ballet, Agnes de Mille used some square dance movements and certain stances and posturings we associate with cowboys. But she was not really giving us a choreographer's extension of a hoedown. As in her earlier *Rodeo* for the Ballet Theatre, she was using the European tradition of ballet heavily modified by the

American tradition of modern dance of Isadora Duncan and Martha Graham—some of whose devices and movements had already been used on the musical stage by Paul Draper and in films by Gene Kelly.

Our earlier musicals had drawn on a greater range of American—or Americanized—vernacular dancing, a creative theatrical rendering and blending of clog dance, hornpipe, square dance, cakewalk, Charleston, tap—almost anything and everything that would express our attitudes and our lives. And that tradition of song and dance—to which African Americans had made essential contributions—had served our musical theater from the early part of the century, and reached a peak of development in the 1930s. *Oklahoma!* was not, in the phrase of the times, at last a real American musical. It was a revival of the operetta tradition.

Along Broadway one can still hear it said that pre-World War II American musicals were hopelessly naive and would be almost unplayable in revival. Such attitudes may have more to do with theatrical fashion than theatrical aesthetics, and in any case the past four decades have seen important revivals of Kern's *Very Good Eddie, Leave It to Jane, Show Boat* (several times) and *Roberta* (two TV productions); of Cole Porter's *Anything Goes* (twice); of Gershwin's *Oh, Kay!* (three times), *Lady, Be Good, Of Thee I Sing,* and *Girl Crazy;* of Rodgers and Hart's *On Your Toes* (twice), *The Boys from Syracuse,* and *Pal Joey;* of Irving Berlin's *The Coconuts* (originally with the Marx Brothers!); of Bert Kalmar and Harry Ruby's (with the Marxes again) *Animal Crackers;* and of Kahn and Donaldson's *Whoopee!*—we have also reached back for Sousa's *El Capitan* and Cohan's *Little Johnny Jones* (I am making my list from memory and may be leaving out some shows). And there are many other pre-1940 American musicals which should be revived.

I am obliged to add, however, that the productions of

some of the revived shows have been deplorably "camped"—
that is, they have been condescended to—and that some
have been overloaded with songs borrowed from other
shows. But there is no question that they *played*. And in
addition to other virtues, they give a kind of theatrical
enlightenment and pleasure which can come only through a
lightness of touch and of the heart, qualities which have
nothing to do with superficiality or naiveté.

The *Volksopfer* company in the Vienna State Opera
House regularly performs its country's heritage in operetta
in modest but effective productions. It also regularly per-
forms American musicals written in the operetta tradition,
which its singers and dancers can handle well. It does not
seem to occur to the proprietors of our American art centers
that we might be doing the same by the classics of our own
musical theater, but surely we ought to be. And we ought to
be giving particular attention to that period of greatness and
irreverence of the 1920s and 1930s, when our vocal styles
and our dance styles became truly American. And would it
not be right for American opera companies, when selecting
the next season's "light" offering, to think, not once again of
The Merry Widow or *Fledermaus,* but of Sousa's *El Capitan*
or Romberg's *The New Moon*? And might we not think of
Victor Herbert's *Babes in Toyland* as a suitable American
Christmas piece rather than yet another *Nutcracker*?

I am not recommending more big, highly touted pro-
ductions that hope and aim for runs on Broadway. I
am recommending that we have regular repertory com-
panies performing in the smaller auditoriums of our arts
centers, sifting the heritage, choosing their shows care-
fully, discreetly making small revisions in such scripts as
need them (and admittedly some do), and learning how to do
the job respectfully and with an appropriate lightness of
touch. If anyone objects that only big, expensive treatments
can do justice to these shows, I can say that the best

production I ever saw of *The Boys from Syracuse* was in a regional dinner theater. And that the revivals of the Marx Brothers shows I listed above were at the relatively modest Arena Stage in Washington, and were just about exemplary.

In Search of American Folk

Let us say that it is the early 1960s, and let us say that we have an idealistic young man, college-educated from a well-to-do family, who has always liked the musical idiom once called "hillbilly," re-named "country and western" by the music trade press as its popularity rose, and sometimes called "folk," at least in one of its more traditional manifestations. The young man of our story was scouting the South and Southwest of the United States for what he would have called folk musicians. He heard about a particularly gifted string player and singer, Roger Jackson, called "Cap'n J," who lived in a small town in Tennessee in the eastern foothills of the great Smokey Mountains.

I should point out that the definition of folk music then used by academic folklorists was that it is music performed in a traditional style that answers the needs of a small, relatively well-defined community. And for the time being let us accept that definition at face value without making an issue of the fact that it suits the musical activities of our big

city symphonies and opera companies probably better than those of any other group.

When our young scout reached Cap'n J's hometown, he found him playing electric guitar with a quartet that had a second guitar, string bass, and drums, performing "top 40" country-and-western and pop hits on Saturday nights in a small dance hall in the rear of a local bar. The music the local community wanted to hear and dance to of course. And it turned out that the Cap'n's favorites were the then-fashionable jazz guitarists Jimmy Rainey and Jimmy Smith.

Our idealistic young man persuaded Cap'n J that he could have a larger career for himself but that he ought to drop the amplification, switch to a more "authentic, traditional" repertory (by which he meant for all practical purposes switch to older material), maybe get out the mandolin that had been his first instrument, get rid of the group and certainly the drummer, and find himself another string player to work with in duo. All of which the Cap'n was willing to do. Cap'n J also proved himself a gifted player and singer, and a performer of some charisma. Cap'n J was a quite intelligent fellow. With the young scout's help, he made an LP album, hit the college and summer folk circuit, and did have quite a career for himself. His audiences in the 1960s and 1970s were college students of the hippie generation, that singular group of middle-class, neo-bohemians whose vestiges are still with us. (And might those "folk" audiences, in their denims and jeans, remind us of the members of Marie Antoinette's court, dressed up as milkmaids and swains, acting out pastoral games?)

As I imply, the question of whether any of this was "authentic," as the idealistic scout thought it to be, is another matter, and may come down to a question of whether musical authenticity can be equated with "old."

The foregoing story is essentially true, although I have changed names, places, and circumstances a bit. My purpose is not to point the finger but to raise some issues. I shall

also change some names and some geography in the stories
and vignettes that follow.

An academic with a degree in folklore was scouting the
Arkansas hills and found a fiddle player who seemed to be
using "all the old modes." As he headed for the tape recorder
in the trunk of his car, the folklorist's head was busy
drafting a scholarly article on the fiddler, and with the
possibility that he was to discover a whole school of such
"old style" fiddlers of eastern Arkansas. Luckily for him and
for his academic progeny, the fiddler stopped him. "Say, you
read music, tell me if I'm getting this right," he said as he
pulled out a book of late nineteenth-century fiddlers' tunes.
No, he wasn't getting it right. He couldn't read key signa-
tures and wasn't getting the accidentals correctly, the
sharps and flats.

In the mid-1950s a recognized authority on American
folk music received a grant to do "field recordings" in the
rural South. He decided to stay off of all federal highways
(there were few interstates then), and to avoid state roads if
he could, to try to stay on county roads, where the people
were more isolated and the music would be more authentic.
On county roads, he assumed, he could find musicians
singing and playing just the way their great-grandfathers
had, uncorrupted by the influences of commercialism. All
of which implies that if you live on a county road in the
South, you have no radio or television, you may never have
heard of the phonograph, and that there is no juke box down
at the crossroads tavern.

More subtly perhaps, our folklorist is making the
standard Marxist assumption that "top 40" hits in any
category of music are decadent, the results of the corruption
of a once "pure" and "authentic" musical idiom brought on
by the pressures of a capitalist economy and its need for a
rapid turnover of musical hits. Many of his fellow folklorists

and ethnomusicologists make similar assumptions, whether they think of themselves as Marxists or not. And since the "top 40" are decadent, our folklorist does not listen to them. With his grant and his recorder, he tapes a great deal of music, and what he gets in these rural communities is what one might expect him to get in mid-twentieth-century America. He gets imitations, often amateurish imitations, of yesterday's top 40 hits, usually the hits of the performer's adolescence. Wrong chords and blues choruses of 11½, 14, and 13 bars instead of the standard 12 are explained away. "You see, the blues was once a free form! It was only when the blues was commercialized and written down in European notation that it was made into a regular 12 measure cycle!" The obvious interpretation that his subjects didn't know how to count to twelve four beats at a time was ignored, or, if raised, was brushed aside. Also brushed aside or ignored were the obviously requisite comparisons. "Look, here is the Sleepy John Estes record from 1935 your man is trying to imitate, just listen!" He didn't, or wouldn't, listen.

Our folklorist's field recordings were issued on LP records with copious notes, and they received reviews in some outlets with comments about the musical geniuses and indigenous, budding poets still to be discovered in the rural South.

How can one explain such obsessions? It would probably take an astute Jungian psychologist to deal with them fully, to be sure. Suffice it to say that if one is determined to find musical noble savages in the real world, he will find them. Or rather, he will insist that he has found them, whether the people he found are noble or savages or musically talented, or not.

Perhaps the most disturbing aspect of such activity is the patrician condescension it obviously involves. The leading field researcher for a state folk festival invites members of a local tribe of American Indians to come and participate.

And that means, whether he has thought it through or not, that he is inviting them to come to his festival grounds and perform their sacred ceremonies. Somehow the sacred ceremonies of Native Americans are "folk culture." Somehow, they are not central to the total culture of a people. Surely our field researcher would not think of inviting a priest to perform a mass or a rabbi to perform a wedding for the entertainment of the middle-class suburbanite visitors to his folk festival.

Folklorists sometimes assume that one man's musical memory has a wide cultural significance. A field researcher runs across a family which keeps an illegal still in northern Georgia. The family interests him because the oldest male member—a functioning alcoholic—knows some "authentic," "traditional" songs which he sings accompanying himself on guitar. The researcher sees the man as a valuable source of lost music whose recovery will enrich us all. The rest of us might see him as a man who plays and sings some old songs, of whatever origins, which he happens to like and remember—and which may or may not seem memorable to his friends and acquaintances or to the rest of the world.

We might consider for a moment the two most celebrated "folk" musicians of the 1930s and 1940s, Woody Guthrie and Leadbelly (Huddie Ledbetter). Guthrie wrote and performed his own songs. His audiences were limited and, to a large extent, political. The fans of the musical idiom that Guthrie favored may have known and loved Roy Acuff and Jimmy Wakely, but few of them ever heard of Woody Guthrie. Similarly Leadbelly, whose somewhat synthetic repertory was not altogether his own ("Rock Island Line" was a promotional song published for the railroad; "Goodnight Irene" an old waltz; "Bourgeois Blues" a piece of political propaganda written for him; etc.), and whose early communal audiences in Texas and Louisiana are

distinctly matters of doubt. In any case, Guthrie had few fans in Wheeling or Nashville, and Leadbelly certainly had few in Detroit or Harlem.

Currently, there are thousands of Americans who seem to believe that bluegrass music is a traditional style. Actually it dates back no further than the late 1940s, when Bill Monroe assigned the members of his "country" string band (Irish-derived, traditional, but already Americanized through the presence of a banjo) the roles of the instruments in a dixieland jazz band. The fiddle was to be the melody-carrying trumpet, the banjo to take the clarinet's obbligato role, the string bass to play rhythm in "two-beat," etc. Monroe was looking for an appealing style as surely as Glenn Miller or Roger Williams looked for appealing styles, and he took his interesting place in the post-World War II "dixieland revival" as surely as had Turk Murphy or the Grove Street Stompers.

And on the origins of our "folk" songs? The National Tune Index is a project of the National Endowment for the Arts in which all American melodies are to be entered and stored in a musical computer. A researcher enters a melody into the computer's musical keyboard and will automatically be given all uses of that melody and all known melodic lines reasonably close to it. So far, scholars working on the project have gone through pre-Revolutionary and very early American melodies and therefore have had only published music to work with. They have discovered that tune after tune, song after song, which were the fodder of the coffee house "folk singers" of the 1960s and which have been called authentic American folk songs, are professionally written published music from our early history.

Folklorists are also apt to explain that folk music is passed on orally by musicians who are untrained. Many a

lounge cocktail pianist plays his Gershwin, his Porter, and his Beatles by ear. Is he therefore a folk musician? Folklorists may say that conservatories train musicians to play an "elite" music. (As elite as Italian opera, perhaps? Tell that to its huge Roman audiences! As elite as the music which conservatory graduates play for a Las Vegas show? Or in accompanying a Hollywood movie?) They often say that "popular" music is ephemeral and folk music durable. (As durable as Stephen Foster, Victor Herbert, Scott Joplin, and Richard Rodgers perhaps?)

Folklorists also tend to subsume with a certain recklessness. A recent dissertation in folklore treated the history of African American musical theater. Surely such theater composers as Eubie Blake, Maceo Pinkard, and James P. Johnson would want to be judged as professionals, judged by the same standards as Irving Berlin and Jerome Kern and not patronized as "folk" musicians. Even the idea of an American folk culture can be recklessly subsuming and seductive to the unsuspecting. In the 1970s, Duke Ellington was called a "folk" musician in the public press by the head of one of our most prestigious cultural institutions. (Did a more professional musician than Ellington ever exist?)

In traditional European culture, a culture with a landed gentry, a courtly aristocracy, and a peasantry, the distinction between "fine" art—a "courtly" or "elite" art— and a folk culture, reflects realities, and therefore makes sense as a way for scholars to approach and research that culture. In a democracy like ours, it seems to me that it does not make sense. Or at any rate, that its validity remains to be demonstrated. Any researcher who assumes that our country has a "folk" and an "elite" puts himself in danger not only of making scholarly blunders but also of assuming a patrician stance and, most dangerous of all, of imposing his unconscious assumptions about noble savages on other people, of molding his ideas about their lives and their

culture after his own unconscious and unacknowledged needs. And should we not also remind ourselves that a basic tenet of the scientific method is that whatever cannot be clearly defined cannot be studied?

In any case, it seems to me that academic folklore has gone on a strange route since the time of Richard Chase, who not only collected the "Jack" tales in rural communities but could discuss with discernment the aesthetic of the American novel with his students. And of Roger Loomis, who regularly asked his students at the University of Pennsylvania to evaluate the *literary* merits of the various versions of the Arthurian romance.

Out of
the Pulps

A FEW WORDS FOR W. R. BURNETT

W. R. Burnett died April 28, 1982. If the members of our literary establishment had taken note of the event, I would have been surprised. But I think they might have, for in a few of Burnett's works we can find a gritty, tragic sense of the human condition that has eluded some of our best writers. Burnett wrote the novel *Little Caesar* in 1929; he helped write the screenplay for *Scarface;* he collaborated (with John Houston) on the screenplay for his own novel *High Sierra;* and he Americanized for the screen the hero of *This Gun for Hire* by Graham Greene, a writer who much admired Burnett.

Between his novels and his screenplays, Burnett probably wrote in almost every genre of fiction the century has offered, but his best works would be called novels of violence—gangster tales. In his stories of American gangsters he undertook to examine some evident and command-

ing figures in our national life. He also tried to understand them and the meaning of their lives in ways that Hemingway or Fitzgerald or Dos Passos or James T. Farrell did not. In his doomed protagonists Burnett sometimes caught an irony and a convincing last-minute glimmer of hope that can engage us all. And in dealing with their ambition, their determination, and, yes, their ruthlessness, Burnett was surely inviting us to examine our own.

In that sense, W. R. Burnett's gangster stories were American tragedies. And if I do not suggest that he functioned on Faulkner's level or on Melville's, I do suggest that a thoughtful comparison of Burnett's fictional world with, say, the passive tragedies of Theodore Dreiser would be worthy of both writers and instructive on the perception of each. Such a comparison would have to question which writer had the more penetrating view of the value of the individual's deeper relationship to the world around him—a question that is surely worth raising, particularly in view of Dreiser's Marxism.

Most book reviewers would call W. R. Burnett's books the work of a "genre writer." To academics, despite his several awards and honors and despite Graham Greene's admiration and William Faulkner's, he would be a "popular" writer, and he typically worked on film scripts at that—and received most of his awards for them. Therefore, the sort of comparisons I am suggesting are not apt to be undertaken, at least not any time soon. But it may be that writers, like Burnett, who face up to certain urgent realities in American life, and who accept and probe some otherwise neglected attitudes in our culture—it may be that such writers discover things that the American arts might encompass, even if they themselves may not quite succeed in literary terms.

If the United States could be said to have a national literature, it is crime melodrama. By that I do not mean that it was an American, Edgar Allan Poe, who established the

modern detective story. I mean that the bulk of our fiction is probably cops and robbers stories. I mean that an average American novel, film, play, or TV show that offers crime melodrama is more than likely to be competently done. I mean that even a poor one can be interesting and entertaining in one way or another. I mean also that in our fiction the western bad man and the big city gangster are virtually interchangeable types. I mean, further, that an outstanding directorial reputation in films can be built on a well-done crime movie. No one seemed taken aback when John Houston, having done a good job with *The Maltese Falcon,* moved on to the likes of *Moby-Dick* and Holy Writ.

Our more moralistic observers have told us that our crime fiction glorifies the criminal. The charge is sometimes glibly delivered but it cannot be glibly answered. By way of an answer, one could reasonably postulate that the fictional criminal is often a complex being and hence he is potentially a dramatically interesting being.

Without attempting to exhaust the subject, let us try a somewhat different tack. Symbolically, the criminal of fiction has made the first decision of masculinity—that is, he knows what he wants. It may be that he has made this decision unwisely, but that is not the point. He has not, however, made the first decision of maturity, which is to acknowledge and accept the responsibilities and the consequences that go with getting what he wants. Thus it is possible for the average gangster film to lull its audience into a kind of easy wish-fulfillment. Get them to identify with a protagonist who takes what he wants, guiltlessly, ruthlessly, and regardless—that is, regardless of everything except the usually required moral ending in which the protagonist is rather arbitrarily arrested or shot down or whatever.

The gangster protagonist is potentially a tragic being if he discovers, usually by falling in love, that he does have within him some regard for the desires and needs of others.

But such a discovery usually comes too late for him, and in coming too late, that essential discovery may doom him. Thus James Cagney's Chicago hoodlum in *Public Enemy*. Or Humphrey Bogart's prison escapee in Burnett's *High Sierra*. Characters like these in our crime dramas and westerns probably bring us as close to true tragedy as any of our fiction.

As I say, I do not mean to imply that I find W. R. Burnett a major writer or even a great writer of the second rank—a writer in the company of Howells and Dreiser, let us say. Reading *Little Caesar* in the 1980s, I was struck by the obvious debt of his terse, abrupt prose style to Hemingway and Dashiell Hammett, yet also struck that there is nothing in *Little Caesar* that quite achieves the cold, banal menace which Hemingway's "The Killers" achieves in only a few paragraphs, but Burnett is after something different of course, different and more cumulative. Nor do I think that *Little Caesar* exposes the American success myth quite as effectively as Dreiser's *The Financier* and *The Titan*, but that is perhaps because in Dreiser's Copperwood we have an effort at a realistic portrayal of the American dream. Burnett's ambitious gangster, Rico, necessarily presents it as a kind of dark parody.

As I say, *Little Caesar* is a parody that is instructive about Dreiser's accomplishments and Hemingway's, but it tells us something about their failures, as well. And it is a novelist's effort to depict and understand aspects of twentieth-century American life, aspects that Hemingway, Fitzgerald, and even Faulkner barely chose to acknowledge.

AND A FEW WORDS ON MAX BRAND

The pulp magazines were born of the dime novels and popular "story" magazines of an earlier time. They grew up

in the 1910s, flourished in the 1920s and 1930s, took sick in the 1940s, were all but dead in the 1950s, but were given a temporary last-minute rescue of sorts in the 1960s by paperback reprint revivals of such characters as Doc Savage, the Shadow, G-8 and his Battle Aces, the Spider, and the Phantom Detective.

The pulps were a phenomenon with considerable cultural resonance. They involved the likes of Jack London, the editorial work of Sinclair Lewis and H. L. Mencken, the illustrations of N. C. Wyeth, as well as the likes of Edgar Rice Burroughs, and the American publication of British writers as wide-ranging as H. G. Wells and Sax Rohmer.

There have been a few nostalgia-oriented volumes on the history of the pulp magazines: light, entertaining affairs, written after the manner of a man who still wants to keep the affair going but who has recently decided that his mistress is something of a moron. Most of these histories have declared that this huge mound of western, seafaring, sports, foreign legion, love, jungle, planetary, detective, and superhero adventures represents the fantasies of adolescents—something which might also be said of the *Beowulf* or *Ivanhoe* on the one hand, or Batman comics on the other, with the tales of Jack London lying somewhere in between. However, in the depression of the 1930s, particularly, pulps were mostly bought by lower-class adults who had ten or fifteen cents but didn't have the price of a first-run movie.

Do the pulps deserve further literary attention? After all, Jack London is firmly in place in American letters, and Dashiell Hammett and Raymond Chandler, some science fictioneers, and an interesting horror monger like H. P. Lovecraft have been rescued by their followers or their cults and the case for their merits made. Why not leave the rest of this heap of rubbish, this storeroom of yesterday's junk, to cultural historians and social scientists?

I can best answer from my own experience and through the example of a writer whose real name was Fredrick Faust, whose best-known pseudonym was Max Brand, but who was prolific enough to have used at least eighteen other pseudonyms. My reading of Max Brand has been quite casual and has not included such westerns as *The Untamed* or *Garden of Eden* or *Tralin'*, which are mentioned by his followers. But it has included five short stories and four novels. The short stories were all based on clever plot gimmicks and surprise twists and, although thinking up such gimmicks and twists is not an easy task for most of us, they read as though almost anyone of fair storytelling skill who could have thought up the gimmicks could have written them.

Of the novels, I found two unreadable and gave up. A third began with clichés of situation and character. But these personages soon became not so much stereotypes as archetypes. And by observing them almost entirely through action and speech, Brand was soon able to give their beings and their world some of the substance of life. Brand's style—lean, admirably colloquial, full of cadences refined from American speech, apparently humorless—is the rightful style of a teller of tales, more specifically, a teller of tall tales, and therefore with an occasional hint of sly self-parody.

The fourth novel, with the banal title *Torture Trail*, was an "Alaskan western," ostensibly about gambling debts and dog-breeding and dog-racing, and briefly featuring a thoroughly wooden female character who set its action in motion. But Brand was actually undertaking a more difficult and introspective task. He gives us a hero to whom most things came easily, and had him, compulsively and unreasonably, thrust his easy arrogance into a situation of great physical and psychological peril. *Torture Trail* is a novel of the significant action of self-discovery and fortitude, more

impressive, in some respects, than *Robinson Crusoe*, and certainly as accessible.

All of which would suggest that a literary job remains to be done on Max Brand as a kind of American Balzac, a difficult job of sifting, discarding, weighing, and evaluating. *Torture Trail* suggests that there is gold to be panned.

HAMMETT, CHANDLER, AND MACDONALD

Edgar Allan Poe's tales of terror had their influence on pulp stories in the 1920s and 1930s, particularly in *Weird Tales*, a pulp that never sold very well and which was perpetually behind in paying its writers. The heir to Poe most frequently mentioned is H. P. Lovecraft, but there is a significant difference between them, it seems to me. Lovecraft gave us a macabre underground world of evil spirits, demons, and devils, almost medieval in its complexity if not in its implied moral basis. Poe was far more apt to locate the impulse for human evil within man himself.

Poe's tales of ratiocination, his mystery stories, had a more important influence in the pulps, and, as has often been said, the modern mystery story took an important step in the pages of *Black Mask* magazine with the introduction of the "hard boiled" tale and the private detective as narrator, a genre which was best realized in the stories of Dashiell Hammett and Raymond Chandler.

Hammett, someone once remarked, took murder out of the drawing room and put it in the streets, where it belongs. Yet anyone who has read *The Maltese Falcon* knows that it is built of the stuff of international romantic intrigue and adventure. Anyone who has read *The Thin Man* knows, its mordant tone being granted, that it is a romantic comedy which includes a murder puzzle, a murder with perhaps as little real blood as the corpse in the library in a Philo Vance story. And anyone acquainted with the work of real private

investigators will know that the fictional private eye is himself a figure of fantasy, although a meaningful one.

In a 1948 essay, "The Guilty Vicarage Notes on the Detective Story, by an Addict," W.H. Auden acknowledged that "detective stories have nothing to do with art," that genteel puzzle tales of murder-in-the-countryside have to do with the violation and restoration of innocence. But, Auden continued, Raymond Chandler's books are "serious studies of a criminal *milieu*," and "should be judged, not as escape literature but as works of art." They leave the world of escapist *genre* books and must take their chances as literary works.

Almost all of us read some mystery stories, although it seems that more men read them than women. Our book review publications regularly give them space and even our political and slick-paper weeklies are apt to. Anyone who doubts that Hemingway had read his Hammett, or that Faulkner had been reading Hammett's episodic *The Dain Curse* when he wrote *Sanctuary,* might be invited to read them all again.

I suspect that we read all mysteries, even Hammett's and Chandler's, for a kind of reassurance. All of them, whether their murders take place in a parish house, a big city duplex, or a dark alley, give us a world gone awry, a world into which murder has intruded. The detective intervenes, finds the hidden source of the evil act, and rids the world of it. The source of evil is of course always somebody else, and we are apt to finish a mystery feeling comfortable about ourselves, our own temptations to evil largely unengaged and unchallenged. For that reason, Edmund Wilson's succinctly titled essay "Who Cares Who Killed Roger Ackroyd?" can make us uncomfortable. Whether we acknowledge it or not, we all know the essential triviality of the *genre*. We may not be sure who the bad guy is in a mystery story, but we know who the good guy is. He is us.

As the central character, the detective is really a kind of outsider. Traditionally, he (or she) engages in no significant dramatic action; solving the case puts him through no moral crisis, offers him no insight into his own character or motives. He leaves the story as he entered it. If he uses drugs (Sherlock Holmes), cannot abide women (Nero Wolfe), or is an incipient alcoholic who also mistrusts women (Philip Marlowe), we put up with him so long as he can find the right scapegoat for the rest of us.

I remember reading a fascinating essay in the 1960s (but which I have been unable to track down since), which suggested one way in which the detective might be deeply involved in the dramatic action. Working out his thesis clue by clue in rational style, the writer argued that in "The Murders in the Rue Morgue" detective C. Auguste Dupin had managed to blame the escaped orangutan for murders he had himself committed. The idea is intriguing surely. At any rate, it exposes the essential dramatic and moral flaw at the center of the mystery story.

In Lew Archer, Ross Macdonald gave us a private eye of more complex character and placed him in plots that involved archetypal actions, usually variations on Oedipus and Orestes-Hamlet. Macdonald's locales and his characters have a rare reality and vividness. His prose is flexible and resourceful. And however much Macdonald (or his detective narrator Lew Archer) sees his characters and their motives with a suspicious eye, he does not see them with a contemptuous eye. He seems to accept them, even in a sense to love them, as he finds them.

Macdonald also knew that in fiction, action is character. His world is not the boyishly naive world of Hammett and Chandler in which the rich are all decadent (although for Macdonald many of them are) and the police as corrupt as the politicians. For Macdonald, moral choices are difficult choices, and the line between good and evil is not crisp and easy. But for all that, in the significant central action of

the stories the Oedipal analogies of *The Dain Curse,* the Orestian quest of *The Far Side of the Dollar,* the Electra-like framework in *The Zebra-Striped Hearse,* Archer can observe, report, and solve a puzzle only as a combination chorus and *deus ex machina.*

As his work evolved, Macdonald was at some pains to involve Lew Archer in the central action and the moral ironies of his stories, and *The Doomsters* (1958) clearly shows Macdonald loosening the hold of Hammett and Chandler on his writing. In *The Doomsters,* Archer's earlier, almost callous refusal to help a young friend at a turning point in his life may have caused a murder and confirmed the young man's entry onto a self-destructive path as well. And Archer's decision not to report another murder to the police may have caused a third. The story's denouement is not complete until Archer has come to terms with his own involvement in the case and his own failures. The noun of the title, *The Doomsters,* comes from a poem by Thomas Hardy, "To an Unborn Pauper Child," but it might be better to take the doomsters as the furies of Aeschylus, and take the central situation as a family curse that falls on three generations. Further, Macdonald's use of archetypal and mythological resonances here seems a part of a creative act and in no way imposed on his tale nor invoked simply to give him a pretentious framework for a tale to tell.

I am aware of two other mystery novels which have involved their detective protagonists in the moral action of their plots. In Roderick Thorpe's *The Detective,* a police investigator, in order to solve his current case, must come to terms with the fact that, perhaps through his own bias, he has arrested the wrong man in a previous case and seen him through conviction and imprisonment.

Scott Turow's *Presumed Innocent* returns to the gimmick of Agatha Christie's *The Murder of Roger Ackroyd* and undertakes to deal with it on a different level of character and motive. Turow's narrator, a quasi-detective lawyer,

gradually reveals that he himself is guilty, and more deeply
guilty than anyone but himself can know.

Thorpe's *The Detective* otherwise seems to me a padded
and somewhat sensational story. And I admit that at the end
of *Presumed Innocent,* I felt uncomfortable, even somewhat
betrayed, by the revealed pathology of the narrator and his
now-revealed commitment to an evil act and the evil pursuit
of its consequences. At any rate, I had felt no pity and terror
for him, and therefore I had none to be purged by the story's
solution.

In Ross Macdonald's world, moral choices may be
difficult and ambiguous, even his murderers may engage
our pity and our terror, and in the end, the innocent may
suffer as much from evil acts as the guilty. His is basically a
tragic view of life.

Perhaps I have not said a great deal here about Ross
Macdonald that has not been said before. But what about
Auden's challenge? How would one rate Macdonald finally
as an artist, as a novelist of character? Rather than attempt
to address that question directly, it might be fruitful to pose
another question in its place. If one were to list, let us say,
twenty of the most interesting American novelists of the
first two decades following World War II, would not Ross
Macdonald need to be one of them?

SPEAKING AS A NOVELIST

Stanley Kauffmann, finding himself with a minority opin-
ion of Truman Capote's *In Cold Blood* in 1965, recom-
mended John Bartlow Martin's fine case-history study *Why
Do They Kill?* for insight into the minds of rampant,
unmotivated killers. I would also have suggested John D.
MacDonald's 1960 novel *The End of the Night.*

No, John D. MacDonald was not Ross Macdonald of

the Lew Archer stories (the private eye as a sensitive, wounded moralist). John D. MacDonald was the author of the Travis McGhee series (the private eye as a preachy hedonist), and admittedly a less likely candidate for the kind of superior novelist's insight I am claiming for him here.

The End of the Night may even have used the same case as Capote's fact-crime book, but only as an oblique point-of-departure. MacDonald's view of what his fictional journalists called "the wolf pack killers" was that of a novelist, and his effort was to depict, through an imagined particular, how so terrible a thing could happen.

MacDonald was, goodness knows, a winning story-teller, the kind of storyteller, as Geoffrey O'Brien has remarked, who could spin essentially the same tale more than once and make us like it. In his few essays on writing, MacDonald showed little patience and no interest in discussing the subject except as craftsmanship and a kind of trial-and-error hard work. His craftsmanship is everywhere in evidence in *The End of the Night,* but he repeatedly transcends it. MacDonald really wants, and wants us, to understand, and his commitment is not so much to the events of his narrative as to his characters and the substance of their lives.

The story is told us largely through a series of documents. We begin with a letter to a friend from the wolf pack's executioner, an unexpectedly touching document in part because it reveals that his wife has to stay away from him for a while after each state-ordered execution.

We learn parts of the story from the killers' lawyer, Riker Deems Owen, whose memos on the case reveal an inflated self-importance which we sense he could never come to terms with, and which prevents him from relating to the killers with even a lawyer-client understanding.

For the most ironically cruel death (and the most difficult for the novelist to handle therefore), the killing of a woman on the verge of middle age and a very promising

marriage, MacDonald uses an early, sudden flash-forward, told through the novelist's omniscient third person, and there are periodic returns to that thread of his story.

Mostly MacDonald gives us excerpts from the death house diaries kept by the most intelligent and articulate of the pack, an upper-middle-class college student, Kirby Stassen. It is he who shows us the other pack members— Sandy Golden, a would-be painter with a failure's need to control others; Nanette, a rather dissolute and sexually available hanger-on; and Hernandez, an almost mindless whipping-boy distinguished only by his repressed bitterness toward his companions.

MacDonald was, as anyone who has ever read him can attest, a master of the vivid, quickly introduced incidental character and setting—the kind of vignette which might disappear from a book within a few pages, but from the reader's mind perhaps never. Here, among others, there is Pearl Weaver, a feisty widow in her seventies, piecing out an existence as proprietress of a once-prosperous motel on a highway now generally not used because of the turnpikes. She escapes the pack's almost casual hit-and-run attempt simply by plunging into a ditch at the right moment, still puzzled at what those strange young people were up to. And there is a small-town sheriff who got into the case frankly because he is after publicity for his re-election, but who comes up with a shrewd guess as to the pack's likely movements.

Early on, we learn that during his adolescence Stassen had observed his parents in the throes of love-making at a time (to make it worse) when he was bitterly angry with his tyrannical father over a harsh punishment. We also learn that the ambitious father had outlined a life for his son which Stassen would have found meaningless. Stassen reacts to Riker Deems Owen's supercilious questioning by protesting that the victims were inferiors whose lives didn't matter. We have observed Stassen in a love affair, the kind

of experience which just might have redeemed him, but it was with a calculating, married actress who skillfully played the coquette and then used him cruelly to humiliate her alcoholic husband. Clearly, in falling in with Sandy Golden and his group, Stassen had taken up with what used to be called "bad companions." And we watch as his conscience is destroyed by drugs.

Any of these experiences might be seized upon by a social psychologist to explain Stassen's heedless conduct. For MacDonald, however, such facts about his characters are facts among other facts, and he is too much the novelist to offer us any facile or reductive interpretations of them or their consequences. Indeed, Stassen himself, when he is not reacting to his lawyer's officiousness, will not allow himself to make excuses. But it is he who raises a core truth, almost casually and without regret, in one of his diary entries: he had joined the slaughter, he decided, because he had no capacity to love.

In the heritage of a mid-century American writer like MacDonald there is a twofold temptation to cynicism which comes from the boyish disillusionment of Hemingway on the one hand, and from the implicit bitterness of Dashiell Hammett on the other, and many a popular novelist has succumbed to it. John D. MacDonald did not, and I think it was because one might say of him as he says of one of his characters here, that he was a devout man, "respecting the living materials that yielded to his skills."

The End of the Night might be praised as a provocative social document in terms of what MacDonald perceived lay ahead as 1950s on-the-road beatniks became 1960s hippies, and turned more and more to drugs. But again, our author remains a novelist. He gives us the imagined particular made real, and he shows us that the novelist's art can make us understand in ways that case histories and social theories cannot.

There is another MacDonald I would recommend: A

Key to the Suite, written at the time of such popular "exposé" novels and movies about the ways of big business as *Executive Suite, It's a Woman's World,* and *Cash McCall.* When we discover that MacDonald has centered his tale upon a huge sales convention we are prepared for corporate plots, managerial back-biting, multiple bed-hopping, and a public disgrace or two. What he gives us, in part, is a basically decent man who is given the position of a kind of corporate hatchet man, learns that he likes the new power he wields, and chooses to suppress the evident coarsening effect it is having on his character, conduct, and relationships, including his almost idyllic marriage. Any popular novelist who undertakes such a theme in our time without using his central character as a simple villain on the one hand or making excuses for him on the other might be entitled to respect. MacDonald convincingly does neither. And how about this for stage and mood setting: "the huge hotel, now being brushed and polished . . . was like some bawdy, obese, degenerate queen, who, having endured a prolonged orgy, was now being temporarily restored to a suitably regal condition by all the knaves . . . who serve her."

Little Caesar most recently re-appeared in a paperback from Carroll and Graf.

Max Brand's *Torture Trail* has had several paperback appearances in recent years, and will probably have several more, and is therefore not hard to come by.

Fawcett, John D. MacDonald's paperback publisher, now part of Random House, has not yet reissued *The End of the Night,* but a trip to any well-stocked used book store should easily turn it up. You might even find *The End of the Night* in its original hardcover edition from Simon and Schuster, and if you do, hang on to it.

THE COMICS

CELEBRATING SEGAR

The elements of the comic strip were already there. Draw-
ings in succession depicting a continuous action, an event,
an anecdote, are as old as cave paintings and have been used
in Greek temple reliefs and Giotto frescoes. "Talk bal-
loons," speeches in enclosed, smoke-like wisps from the
mouths of characters, were common in drawings by the
eighteenth century. Graphic caricature was virtually com-
monplace in nineteenth-century Europe. And in the late
nineteenth-century British "comic papers," there were
captioned cartoon narratives offering farcical incidents and
anecdotes, mostly derived from the traditions of circus
clowning and music hall sketches. It remained for the
United States, in its time of growing mass communications
at the turn of the century, to put all these elements together
and make something new of them.

Our early comic strip artists were largely self-taught.

Whatever they may have learned as apprentices or picked up in correspondence courses or have been taught in art school classrooms, they (like our early film-makers and our early jazzmen) evolved their own medium of expression and their own styles. They had their attitudes about the human animal and his foibles, and their drawing styles became a functional means of expressing those attitudes. Their artistic and dramaturgical standards were (for them) largely of their own creation. Those artists, discovering the new American medium of the strip cartoon, and discovering themselves, came up with their own kinds of talent, their own kinds of craftsmanship, and (in some few cases) their own kind of popular genius.

What might it take to do full justice to a good comic strip? Some knowledge of what constitutes good graphic caricature and good, balanced compositional design. A knowledge of the standards of good dramatic dialogue and characterization, and at the same time a knowledge of good comic dialogue and comic pacing. A knowledge of good narrative structure and technique. Some knowledge of satire, parody, burlesque, and lampoon and the distinctions among them. And an ability to apply all such standards not rigidly but appropriately. Standards and traditions which European scholarship and criticism have been sorting and refining for several centuries, and which several European observers have used to comment interestingly on our comic strips. Many American observers who have turned their attention to strips seem not only not to know those critical traditions, they seem not to care about them. Some treat comics as "popular culture." They seem particularly interested in things like the appeal of super hero comic books to adolescents and they use the jargon of sociology to attempt to explain such things.

The first strip to attract the attention of intellectuals was George Herriman's *Krazy Kat,* and Krazy was the subject of probably the best essay in Gilbert Seldes's *The*

Seven Lively Arts in 1924. Soon after Herriman's death in 1944, E. E. Cummings wrote an essay on Krazy (the point of which, I must admit, I am still trying to discern).

Krazy was also the delight of the newspaper magnate William Randolph Hearst and that kept the strip going in Hearst's papers because it was never widely popular in its time. Herriman took the cat-and-mouse game and turned its farcical potential inside out, making Ignatz Mouse the brick-tossing aggressor and awarding Krazy Kat both an intermittent Yiddish accent and the pathos of a turn-the-other-cheek forgiveness.

Herriman's full Sunday pages were apt to be dazzling graphic designs, but the master of graphic design in the early strip was Windsor McCay in *Little Nemo in Slumberland*, who, in another age, might have been adorning the walls of Italian Renaissance palazzos with dazzling perspective paintings. McCay also had a talent for narrative, and the Sundays-only, surreal near-nightmares of his youthful protagonist Nemo have a force and interest that goes beyond McCay's singular talent for drawings-in-depth.

The comic strips from the 1930s which have generally received the attention and praise of aficionados include Harold Gray's *Little Orphan Annie*, Chester Gould's *Dick Tracy*, Milton Caniff's *Terry and the Pirates*, Al Capp's *L'il Abner*, and E. C. Segar's *Thimble Theater*.

*Thimble Theater** had started in December 1919, but not long after the introduction of a tough, pugnacious, low-life sailor in January 1929, he took a leading role and newspapers began calling it *Thimble Theater, Starring Popeye*.

Segar's strip is difficult to discuss both because of some of the uses to which the Popeye character was put during Segar's lifetime—he died in 1938—and because the strip

* The spelling settled down into the American preference. Early on, *Theatre* was used, and may have been Segar's own preference, perhaps in irony at the anything-but-elegant little dramas of the strip.

has been continued by others since his death. The real Popeye is not the Popeye of the animated cartoon or the Popeye of the comic strip since the master's death.*

Gargantua was a popular character about whom many bawdy adventures had been constructed before Rabelais took him on and realized the works of art that center on him. With Popeye, things have worked in the opposite way: he and his best expression were born together in Segar's vision and the rest have obscured Segar's excellence.

Popeye is Segar's Popeye, his one good eye a squint, his bulbous nose flattened in a hundred fights, his cleft chin jutting out in challenge, his huge, tattooed forearms dangling from spindly biceps.

Segar's sailorman, with the "face like a shipwreck," could not solve every problem with a sock in the jaw. Nor was he invulnerable, particularly not psychologically invulnerable. "I hates myskeries," he once confessed in a daily strip, "on account of I kin not un'erstan' 'em." In a later episode, the perpetually worried, slightly mad King Blozo of Nazilia babbled on about "some terrible curse" and "spirits all around us." Popeye retorted, "Shut up! Ya knows I yam askared of ghosks! Pipe down!" And in a subsequent Sunday page, he further admitted: "Don't talk abut skeletons an' ghosks on account of that's the only two thinks I yam scared of, except evil spiriks."

Or take this early, bantering burlesque of a press agent's attempt to change the image of an underpopulated, depression-ridden country. Popeye, followed by his temporary secretary, the gangling Olive Oyl, approaches a farmer. His fists wouldn't help him here:

* There have been several series of animated Popeye cartoons beginning in 1932, first from the Max Fleischer studios, then Fleischer's successor, Famous Studios. These were shown on early TV, and were followed by (to date) no less than three series of made-for-TV cartoons. Segar's successors on the strip as cartoonists and/or writers have included Tom Sims, Bela Zaboly, Bud Sagendorf, and Bobby London.

Popeye: Mr. Smith, we're gettin' material for broad-
castin' over the radio to get people to come here—are ya
happy?

Farmer: No!

Popeye: Yer not happy?

Farmer (*gritting his teeth on his corncob pipestem*): No!
No! No! No! No! No! (*And each no is inside its own comic
balloon sprouting from the farmer's head.*)

Popeye: What 'sa matter?

Farmer (*still gritting*): The jay birds eat up my seeds—
when I plant seeds the jay birds eat 'em up—the jay birds eat
up my seeds. (*Continuing and gritting harder*) The ground is
so poor it wouldn't raise a dust—and another thing—here's
another thing—when I plant seeds the jay birds eat 'em up!

Popeye: How do you like our climate?

Farmer: It's okay.

Popeye (*turning to Olive*): Put Mr. Smith down as
saying we have the most wonderful climate on eart'—an'
mention about the little jay birds flittin' aroun' in the
sunshine. An' he says they is no dust.

The Farmer, falling out of the lower-right corner of
the last panel, makes a comic strip PLOP!

Of course, the sailor would always employ his dukes if
the situation called for it. The opening panel of a Monday
strip in the mid-thirties summarized the plot-so-far this
way: "Reporter Popeye, finding no news about town, de-
cides to make some. So he socks a big brute and is now all set
to write a story about finding an unconscious man lying on
the sidewalk."

I believe a reader can sense the superiority of Segar's
strip immediately, in the crackling, lowbrow terseness of
the dialogue, the swift confidence of the characterizations,
the lively variety of incident which first establish them-
selves by their vividness and soon reveal themselves to be of
more durable stuff.

Then there is Segar's mastery of the strip idiom, with

its requisite daily rise to a gag or suspenseful surprise, while it may also serve to move plot or incident forward. And there is the overall air of sureness with which Segar goes about his comic tale-spinning. It may be difficult to think of such raucous low comedy as mature, but by the mid-thirties Segar had matured. Indeed, the air of confidence is there even when Segar falters. Narrative needs incidents, and good farce comedy can always accommodate seemingly tangential or interrupting incidents as long as they maintain a tone or an attitude. "Fire!" General Wimpy orders his one-man army. "Fire! I said fire!"

"I'm too tender-hearted," objects the tiny, rifle-holding private.

"Fire!" Wimpy continues for two panels, with increasing loudness. "Fire, I tell you. Fire! FIRE! FIRE! *FIRE!*"

Enter an angry, harassed hook-and-ladder crew, sweat droplets cascading from their brows, dragging a lengthy hose. "Where's the fire?"

Wimpy: "I beg pardon?"

Private: "?"

In praising Segar's confident mastery of the idiom, perhaps I have been raising issues only of good craftsmanship. But, as I say, Segar's strip also shows the stuff of comic-strip genius. He had found the character of Popeye within himself of course, and once he found him, Popeye asserted himself, took over, and went virtually his own way, taking the strip along with him. Segar's previous work had largely been handed to him. Help several other cartoonists provide Charlie Chaplin with a Sunday comics page, he had been told early in his career. Try a strip that will appeal to commuters who are reading the paper on their way to and from work, he was told later. Try something like C. W. Cahles's *Hairbreadth Harry* or Ed Whelan's *Minute Movies,* burlesques of movies and movie serials. Thus, *Thimble Theater.*

Popeye was introduced in that seafaring episode and

Segar simply had to go with him, but not because the public responded to the new character. The public responded because Segar's best sensibilities responded. He had found a character who could carry his strip from the center far better than his previous central character, Casper Oyl, a hustling promoter, and far better than Olive Oyl and her perverse pursuit of a character named Ham Gravey.

All comedy—perhaps all story-telling—begins with stock character types; quality depends on what an artist does with them. With Popeye there, Olive moved beyond the homely man-chasing spinster and found for herself a kind of independence and even poignancy and tenderness. Casper's hustling sifted down to his self-promotion as the "world's greatest detective," and behind his perpetual scowl, we were allowed to glimpse the sadness inside the braggart runt. And J. Wellington Wimpy was introduced and grew rapidly into a comic wonder.

Wimpy has slits for eyes. That is, he was meta-phorically blind: he saw only what he wanted to see, at first as a comic referee in the boxing ring, then in the world at large. And he desired only one thing: to feed himself without ever having to work (perhaps that's two things). Of course he was invulnerable to the evil curses of the Sea Hag and to the ghostliness of Alice the Goon Girl: they had nothing he wanted unless he could make them his partners as he exercised his con man's charm, which he did. Wimpy was part conniving W. C. Fields, part baby, always offering gladly to pay on an unspecified Tuesday for a hamburger today, grandly inviting anyone to his house for a duck dinner ("You bring the ducks"), or cunningly proposing "Let's you and him fight" at the slightest hint of friction between anybody and anybody else, as long as neither of them was J. Wellington Wimpy.

Beginning with Popeye's presence in the strip, Segar seemed to come up with one new supporting comic charac-ter after another. Roughhouse was already there as the

proprietor of the grubbiest, smelliest waterfront cafe that
the mind of man and the cooperation of house flies ever
conceived. There was his competitor, tangle-bearded
George W. Geezel, looking, as Donald Phelps has sug-
gested, like an unfrocked rabbi, pacing in circles and
muttering, "Bah! Flies in mine zoup? Pooey from me to
you!" Or, "Pooey on you and your whole family!"

Then there was Popeye's "adoptink, infink son,
Swee'pea." He arrived mysteriously in 1933 in a package
marked "express" that went "plomb" or "ga" or "ump" or
"goo" or "zzz" or "urk" or, finally, "rattle! baw! waw!" for
days on end before Popeye finally concluded "Sounds sort of
hooman, don't it?" and opened the box.

The "infink Swee'pea," it soon turned out, would just
as leave bop anybody who tried to chuck him under the chin.
Once Popeye himself almost caught it. "Nice little lolly
popsie poochy woochy," says Wimpy, holding the blank-
eyed baby awkwardly on one arm.

"Here! Cut that out!" growls Popeye. "I don't allow no
baby talk around me little boy kid—it's disgustin'. I won't
stan' it!!

"Besides bein' disgustin'," the sailorman continues, "it
ain't right to teach no kid grammar wich ain't correck." And
taking the little one, he goes on, "He'd ruin ya, wouldn't he?
Heh! Heh! Little ol' Swe'patootsie, bad mans, ain't he?"
And in the last panel: "Arf! Arf! Lil heaven-face. Him's a
nice'ittle feller, tha's what! Woosy-Toosy. Arf."

Wimpy meanwhile says merely, "!"

Then there was Oscar, the bucktoothed simpleton and
Popeye's sometime one-man crew. The sailorman was abso-
lutely merciless to Oscar. "Ya dumb ox! Ya is so stupid I yam
sorry fer ya! Yer ignorance is refreskin'."

Poopdeck Pappy showed up too, Popeye's long-lost
father, whose convoluted irascibility made Popeye himself
look almost detached and benign by comparison. "Son, I
wants to tell ye before it's too late that one't upon a time

many years ago I was soft—I had me share of fights like all sailormen. But I was hooman then—aye, up to the time I was thirty-seven. I be ninety-nine now."

And there were the supernatural characters: gigantic, prehistoric Toar, a caveman come back to life; Eugene the Jeep (who ate orchids, foretold the future, teleported at will, and said, "Jeep!"); there were the aforementioned females, the cadaverous, frightening Sea Hag, with her pet vulture perpetually perched on her shoulder, and Alice the Goon, whose forearms were much more hairy than Popeye's.

Besides these, there were the supernumeraries of the strip: the panicky, pill-pushing doctors; the arrogant, dumbbell policemen; the cunning but decent sheriffs; the bemused and/or confused jurists; the money-crazed industrialists; egomaniacal "diktapaters"; war-crazy generals; and, yes, melancholy cartoonists.

Segar respected his characters, beginning with Popeye, and he listened to them. (Did Al Capp really respect L'il Abner? I don't think so.) Segar would never manipulate them or their natures for the sake of his plot. (Harold Gray did that in *Little Orphan Annie*.) He did not subject them to one unlikely coincidence, then another and another, to keep his gags or his plot line moving. (Capp did that.)

The year 1934 was the year that William Randolph Hearst gave Segar some orders: Popeye had become an idol to young boys, so cut down on all that cussing and all those fisticuffs. Some say that Segar became inhibited by those orders, that he made Popeye downright respectable. But I say that Popeye rose to the occasion. Popeye not only survived, he grew and he discovered parts of himself previously unsuspected. We always knew that, in passing, Popeye might make a fool out of himself, but now the risks of foolishness became larger, and in the sequence called "Popeye's Ark," which ran from April 22, 1935, through March 19, 1936, almost a full year, he gained an unex-

pected pathos in his foolishness. He even found out that, at his best, he could take people as they are—he could do unto them as he had always demanded they do unto him, as he so sublimely expressed it, "I yam what I yam and thas all I yam." He learned a lot more about not using his fists. He found himself in situations where their limitations were obvious and inescapable. In "Popeye's Ark" he was to indulge a new-found idealism, and he was to meet situations which told him his ideals were misplaced.

We may be asked to believe that Superman defends truth and justice (i.e., his idea of truth and justice) by means of superior force, but we are usually allowed to glimpse an absurdity in the efforts of Segar's Popeye to set others straight with his fists. Now, in "Popeye's Ark," we clearly see the absurdity of Popeye's deciding what everyone else's truth and everyone else's justice ought to be. (The animated Popeye never learned that, and there were all those years and all those cartoons with only one, single-dimensional plot!)

"Popeye's Ark" thrusts Popeye's foolishness and failures into the center of *Thimble Theater*'s stage and at the same time makes us love him for his idealism, however misguided. He was willing to fail finally, and perhaps even to acquire a few new attitudes from the experience—while protesting loudly and pugnaciously all the way, of course.

Segar had already spoofed monarchy several times by giving Popeye trips to the kingdom of Nazilia, but he undertook "Popeye's Ark" as a farcical indictment of dictatorship and totalitarianism. In 1935! That was the year that Mussolini invaded Ethiopia, and someone might do well to compare Segar's low-comedy insights on that phenomenon of dictatorship with those of the leading intellectual and political theorists of that year. ("Popeye's Ark" is of course revealing of its time, but bad art does that, and usually more succinctly than good art.)

The sequence also comes from a time when in our pub-

lic arts we understood not only that a light-heartedness of
approach did not necessarily mean shallowness, and that
zaniness didn't have to be simply silliness. We also under-
stood that we didn't become serious simply by taking our-
selves seriously. "Popeye's Ark" survives that time as surely
as Fred Astaire's *Top Hat* and *Swing Time* do; as surely
as Frank Capra's *It Happened One Night* does; as surely as
Laurel and Hardy's *Them Thar Hills* does; as surely as
Ellington's "Solitude" and "Reminiscing in Tempo" do;
as surely as W. C. Fields's *It's a Gift* does; and, to pick
an outlook very close to Segar's, as surely as the Marx
Brothers' *Duck Soup* and *A Night at the Opera* do. It moves
from a preposterous idealism of founding a misanthropic
nation without women. A farcical turnaround of *The Trojan
Women,* and a farcical metaphor perhaps for the equally
naive ideal that if a society satisfies its citizens' material
needs and makes all important decisions for them then
human venality and crime will disappear. And before "Pop-
eye's Ark" is over, Popeye has moved the country of Spin-
ichovia into a failed economy, and into his effort to salvage
that economy by provoking a war with a neighboring coun-
try. (In 1935–1936!)

 "Popeye's Ark" survives the way all real narrative art,
farce comedy through tragedy, survives. In telling us some-
thing about its time, it also overtakes us and tells us
something about our own natures and our essential selves.

IT'S HARD TO BE SERIOUS

Carl Barks and John Stanley have both been called out-
standing contributors to the comic books, and rightly so I
think. Barks, handed Disney's Donald Duck as a comic
book subject, proceeded to invent a fine supporting cast, a
gaggle of geese, chickens, and ducks (it was Barks who

created the miserly, irascible Uncle Scrooge). John Stanley, given Marge's Little Lulu character (Carl Anderson's Henry in a skirt, more or less), developed a townful of kids—plus parents, shopkeepers, teachers, and truant officers—who misbehaved, argued, acted out imaginative childhood games, childhood rituals, and friendly rivalries.

There are some differences between newspaper comic strips, with their need for a daily rise and fall, and comic book comics, which offer self-contained stories, albeit with continuing characters, or serial stories spread across several issues. The influence of newspaper strips on comic books might go without saying, but the reverse influence of the comic book is mostly confined to the intermittent presence on newspaper pages of such successes as Superman, Batman, and Spiderman.

Among comic strip aficionados, Chester Gould's *Dick Tracy* from the 1930s and 1940s is much admired. Graphically, Gould showed flat two-dimensional characters moving through a three-dimensional world, and, although Gould was admittedly a good storyteller, his early plots may seem even less than two-dimensional. At the same time, it may be worth remarking, the *Tracy* strip offered violence, brutality, and gore almost as readily as the movie screen does today. Tracy himself was frankly conceived as a man who combated the gangsterism of the time by shooting first and asking questions afterward, if at all, but who was of course an officer of the law, not a self-appointed vigilante. When gangsterism began to wane, and when the obvious inspiration of the Hollywood "gangster cycle" films did too, Gould began to introduce colorful, bizarre criminals with names like "Pruneface" and "B.B. Eyes" into his strip, and Tracy's crime fighting became a kind of charade of grotesques. A prime example would be a quasi-spy story called "The Brow" from 1944. One false note in Gould's treatment, one hint that a literal reality was being portrayed— one hint, in short, of the strip's former gory seriousness—

and the reader would be reminded of the weakness of it all, reminded, that is, that the strip's view of crime and criminals was basically comedic.

Will Eisner's *The Spirit,* a comic book about a vigilante crime fighter with a sense of humor, was actually distributed with Sunday newspapers. Eisner could spin a tale so well as to make a clichéd plot, or a contrived set of characters, seem almost new. He was not a great figure draftsman but he was a very gifted man both with lively page designs (the big opening, "splash" panels of his Spirit features are particularly striking) and with sympathetic comic caricature. That latter talent is a problem in the long run, for in Eisner's hands, criminals could not help but seem comic and colorful, much like the characters in a Damon Runyon tale, and graft and murder might become as diverting as a small-time con game or hustle.

The Dickensian adventures of Harold Gray's *Little Orphan Annie* adapt themselves readily to a kind of benign caricature, as Dickens's own illustrators had shown. Indeed, it was Dickens's genius to be able to transform benign and sometimes sentimental literary caricature into literary art. But Dickens was always absolutely true to his characters and their natures. Gray was not always. In a 1931 sequence, for instance "Daddy" Warbucks, suffering dire depression-era financial reverses, simply abandons Annie, leaving her alone in a slum tenement because, he says, he doesn't want her to see him as a failure any longer. Clearly the real reason is so that Gray's plot line can be kept moving. A bit later, Annie, a sub-teen, takes in an abandoned infant and takes care of it, frequently leaving the baby alone, with only her dog Sandy in charge.

The question is whether stories centered on murderers and thieves can be told through caricature—in short, whether caricature can be serious without trivializing its subject. Admittedly, in the hands of Chester Gould and Will Eisner, comic tales of big city crime and graft can be

entertaining, and, if the comic strip had produced no works
of art but only skillful entertainments, the matter might
rest there. But the comic strip has produced works of art,
although virtually none of those works has been serious in
tone or point of view.

In 1987, at the time of the successful Vietnam movie
Platoon, and when the Vietnam Memorial in Washington
was obviously becoming a powerful national symbol—at a
time, in short, when Americans seemed to be trying to come
to terms with the Vietnam war and its meaning—a comic
book appeared called *The 'Nam,* conceived and written by a
veteran of that war named Doug Murray. It was praised as
another expression of that same collective national effort.

For its first two years, and particularly when the book's
original artist, Michael Golden, was handling Murray's
scripts, *The 'Nam* was full of promise and even of accom-
plishment. It saw the war from the point of view of a young
enlisted inductee, as *Platoon* had done. It told its story
episodically as a series of vignettes, encounters, and short
stories involving a set of continuing characters. Like a
television series in short (and more effectively, I think, than
the TV series on the Vietnam war, *Tour of Duty*).

Murray and Golden were very adept at a contemporary
cinematic style in which dialogue was not only tersely
condensed but at times elliptical, and successive panels of
wordless close-ups, looks, and slight movements, were as
effective and revealing as in the best silent film drama. Most
significant perhaps was Golden's ability to maintain the
essential seriousness of Murray's scripts, while conceiving
his character designs and their stances and expressions
within the traditions of caricature. Any other approach, I
think, and certainly anything even hinting at a *beaux arts*
illustration style, would have given the effort an air of self-
importance quite out of keeping with Murray's essentially
modest and personal tone. *The 'Nam* showed how a style of

modified graphic caricature can be used, and used well, for
essentially serious purposes.

After twenty issues or so, I should add, *The 'Nam* was
clearly in danger of losing its direction. Much as *Platoon* had
been unable to resolve the larger issues it raised, and settled
into a fairly standard conflict between a brutal sergeant and
the sensitive recruit hero.

I should admit that I approached Art Spiegelman's
Maus with strong misgivings. In the first place, it originated
in serial form in *Raw,* an "underground" comic book of the
1980s, and the earlier underground comics of the 1960s and
1970s had seemed to me to thrive on a kind of smug
adolescent need to shock and outrage. Only a few of their
contributors seemed to me to have the substance and
promise that can make a patient attitude toward adoles-
cence worthwhile. I also knew that the subject of *Maus* was
the persecution and plight of European Jews preceding and
during World War II, and that Spiegelman's Jews were
represented as mice and his Nazis as cats. How could *Maus*
help but trivialize events that brought Western civilization
to a state of moral crisis, a crisis, with implications not yet
fully faced? Having read *Maus,* I have come to an opposite
conclusion. I found it a powerful experience, but I admit I
may not be able to explain its singular power.

Spiegelman has framed his story by using his own
complex relationship with his refugee father, and his need
to hear a full account of the experiences which he knew had
brought that man to the death camp at Auschwitz. And his
need also to know and accept that difficult man, who had
never quite accepted himself or come to terms with the
experience he needs to pass on to his son.

The father's tale is complex as well, for not all of its
minor villains are found among the *goyim* (depicted as pigs).
There are some opportunists among the Jews of his tale
and there are a few genuinely helpful *goyim* (shown as

friendly hounds) with no motives of greed or opportunism.

Perhaps the most puzzling aspect of Spiegelman's accomplishment is how he makes his usually expressionless Jewish mice so appealing without ever letting them seem shallow or empty, without making them clichéd "innocent victims."

There are a few influences on Spiegelman one could point to from earlier strip stories—precious few—comic book stories like "Air Burst" and "Corpse on the Injin" by Harvey Kurtzman and "The Master Race" by Bernard Kreigstein—all three of them, one might note, from EC Comics, whose notorious line of "horror" comic books brought the threat of outside censorship in the 1950s. But Kurtzman's and Kreigstein's were small ironic vignettes compared with *Maus*'s comic novel.

Maus seems to me a major event for the comics medium and an important interpretation of the Holocaust. Lucky will be the future strip artist who can absorb *Maus* and learn from it how the comics can be not only serious but even profound. And lucky their readers.

ARCADIA IN OKEFENOKEE

Cartoonists usually praise Walt Kelly for the sureness of his line, for the adept flexibility of his brushwork, and for his delightfully detailed backgrounds. Litterateurs have praised him for his natural ease with words, his unpretentious grace and delight in puns and other verbal games, in all of which he has been compared to James Joyce.

Certainly, if the idiomatic American comic strip produced a genius after World War II, it was Kelly. And if the comic book produced any geniuses, Walt Kelly was one of them. That latter statement may surprise some readers, for few people know that Kelly worked on comic books from

1941 to 1948, and it was in those comic books that Pogo Possum and Albert Alligator first appeared.

Walt Kelly, born in 1913, was raised in Bridgeport, Connecticut, where he edited and drew for his high school newspaper and went to work for the *Bridgeport Post* on graduation. Between 1934 and 1941, he worked for the Disney studios in Hollywood. The following year, he was in New York City, drawing and writing for a group of comic books intended for small children, with titles like *Animal Comics, Mother Goose and Nursery Rhyme Comics, Fairy Tale Parade,* and *Santa Claus Comics.* Pogo Possum began in *Animal Comics,* but in the beginning a ravenously hungry Albert Alligator was the central character.

Kelly's early depictions of Albert and Pogo were rather different and almost harsh. If we compare Kelly's youthful drawings from his Bridgeport days with his later work, we will conclude that he learned a great deal while working at Disney. But in his early versions of Albert and Pogo, it is as if he were reacting to the calculated, corporate cuteness of the Disney style and trying to avoid it. Within a few years, the early harshness was gone, however, to be replaced, not by cuteness, but by a stylized innocence, even for the still-ravenous and irascible Albert.

In 1948, Kelly took a job as head cartoonist and designer for the short-lived idealistic newspaper, the New York *Star,* and there he began *Pogo* as a daily comics feature. National syndication and success quickly followed.

Pogo Possum had become central to the strip because he had obviously become central to Kelly's inspiration as the detached, boyish *raisonneur* of the Okefenokee swamp and its cast of animals. *Innocence* is the key word, for, as Edward Mendelson has pointed out in an excellent essay on Pogo, Kelly's strip is an American pastoral, and it has the uniquely innocent yet satirical point of view and insight that pastoral can provide.

The daily *Pogo* appealed to adults but Kelly was di-

rectly in touch with children through his Sunday strip, and the Sunday episodes were very like his earlier playfully low-comic, improvisational comic book work. Not that children felt excluded from the daily continuity. The magnificence of *Pogo* was that it could appeal to almost anybody. In the sequence for the week of September 17, 1950, for example, Pogo and the Rackety Coon Chile attempt to bathe Pup Dog in a washtub, and there were all the expected gags— expected but well-timed and personally embellished: Pogo and Rackety Coon end up in the washtub as Pup Dog runs away; Rackety Coon Chile gets tracked and captured in-stead of Pup Dog; Pogo himself ends up getting a bath from Porky Pine, but Pup Dog is discovered in the washtub under the suds. During all this farcical action meanwhile, Pogo and Rackety Coon have been discussing the nature of war. "Jes' who is the enemy in them?" asks the Coon Chile. After a further bit of discourse, Pogo decides "Well, *each* side figgers *they* is the good guys, so, lookin' at it another way, *the whole mess is nothin'* BUT *good guys!"*

"It's hard to figger out how folks kin *fight* each other if *each side* b'lieves they is the *good guys,"* Rackety Coon Chile responds in the next day's strip. Meanwhile still, Wednes-day's strip is a cut-away to Albert who is being flattered and conned by Seminole Sam into writing a book of his memoirs—to be bound in alligator hide, it turns out—while the two of them are involved in falling off a makeshift see-saw, among other simultaneous sight-gags.

Kelly took a personal approach to strip conventions. He avoided the daily gag, built up for two or three panels to a punch line or pratfall in the last. His was a comedy of constant playfulness, which, as I say, typically worked on the levels of knockabout farce, whimsical discourse, and verbal word-play all at once.

Pogo's pastoral swamp could admit the scheming machinations of Seminole Sam, Deacon Mole, and Wiley Catt. And in the Nixon years, Kelly could introduce carica-

tures of J. Edgar Hoover and Spiro Agnew and make them seem absurd, but with an absurdity that may be a part of life, he implies—or which keeps life interesting anyway. But in the 1950s in the character of Simple J. Malarky, Kelly took on Senator Joseph McCarthy as the intrusion of outright evil into the fundamental innocence of Okefenokee, and he thereby risked breaking the pastoral spell. Malarky easily put the scheming Seminole Sam, Deacon Mole, and Wiley Catt to his own uses, but for the rest of the Okefenokee animals, it was their own easy innocence that protected them. They had no real fear of him therefore, and they handled him, by and large, simply by not liking him or the way he behaved. The deeper implications of his evil were clearly there but were left to the reader.

There was more to Kelly's talent than the comic strip. This from *The Pogo Stepmother Goose* (1954):

> Mistress Flurry
> Likes to worry,
> Rises early
> Feeling surly.
> There's no cure
> For she is sure
> Life will be
> The death of she.
> Best to worry,
> Mistress Flurry.*

It could pass for a parody of "Mistress Mary, Quite Contrary" of course, but, more important, it could be Kelly's contribution to Mother Goose, even without the drawings which combine humor and pathos and which go with the couplets.

Or there is this nonsense-verse parody from the same collection:

Oh, pick a pock of peach pits
Pockets full of pie
Four and twenty blackboards
Baked until they cry.

Winnipeg was open,
The burst again to sing.
Oh, worsen that,
A Danish dish
Was two-by-four the King.

The King was in a pallor,
Counter fitting moneys.
The Queen was in a tizzy,
Reading all the funnies.

The maid was in the garden,
Hanging by her toes.
Along came a north wind
And that's the way she froze.*

Kelly did not much like intellectual reactions to his work. Although he did not mention his fellow Irishman by name, he clearly did not like the comparisons of his playful, and telling use of language and its sounds to James Joyce. Kelly did not put his displeasure quite as directly as Duke Ellington had, when he said of analyses of his music, "That kind of talk stinks up the place," but one gets the feeling that for both men, the art was in the doing and anything else takes all the fun out of it. The problem is, of course, that analysis and criticism of each man's work are necessary; without them neither man will be likely to take his place in

the American pantheon. So, for the moment, we just have
to risk stinking up the place.

A collection of essays and strips, *Krazy Kat: The Comic Art of George
 Herriman,* was edited by Patrick McDonnell, Karen O'Connell,
 and Georgia Riley de Havenon (Abrams, 1986).
Windsor McCay: His Life and Art by John Canemaker is a biography,
 appreciation, and anthology (Abbeville Press, 1987).
Fantagraphics Books has published *The Complete Segar's Popeye* in ten
 volumes, edited by Rick Marshall. "Popeye's Ark" is contained in
 Vols. 9 and 10. (Fantagraphics Books, 7563 Lake City Way,
 Seattle, Washington 98115.)
"The Brow" sequence from *Dick Tracy* can be found in *The Celebrated
 Cases of Dick Tracy* edited by Herb Galewitz (Chelsea House).
 Will Eisner's *The Spirit* has not yet seen a book collection but has
 often appeared in comic book reprints, most recently from
 Kitchen Sink Press (No. 2 Swamp Road, Princeton, WI 54968).
 A moving (but untypical) Spirit story is included in *A Smithsonian
 Book of Comic Book Comics,* edited by Mike Barrier and Martin
 Williams (Smithsonian/Abrams).
Probably the best *Little Orphan Annie* sequence is the "Jack Boot" story
 from 1936–37. It can be found in *Arf! The Life and Hard Times of
 Little Orphan Annie* (Arlington House).
Three quality paperback collections of sequences from *The 'Nam,*
 covering the magazine's first twelve issues, have appeared from
 Marvel Comics.
Art Spiegelman's *Maus* is published by Pantheon.
"Air Burst," "Corpse on the Injin," and "The Master Race" are included
 in *A Smithsonian Book of Comic Book Comics,* edited by Barrier
 and Williams.
A complete republication of Pogo's comic book appearances was under-
 taken in 1990 by Eclipse Books (P.O. Box 1099, Forestville, CA
 95436). The verses I have quoted are from Kelly's *The Pogo
 Stepmother Goose,* which was last republished in 1977 by Gregg
 Press.
There should be a complete strip Pogo collection of course, and one has
 been promised by Fantagraphics Books, 7653 Lake City Way,
 Seattle, WA 98115. Meanwhile, there is a series of volumes from

Fireside Books (Simon and Schuster), each of which collects the daily strips a year at a time: as of this writing, *The Best of Pogo, Pogo Even Better, Outrageously Pogo, Pluperfect Pogo,* and *Phi Beta Pogo.* The last volume includes Edward Mendelson's essay, "Pastoral Possum," which is so good that it may leave the rest of us feeling that we have nothing left to say about Kelly's extended masterpiece.

Surely there should also be a collection of Kelly's comic book illustrations of traditional Mother Goose rhymes, his comic book treatments of traditional fairy tales, plus his own playful contributions to that tradition.

ON THE AIR

MR. ALLEN

The career of comedian Fred Allen certainly had its contradictions. Off-the-air recordings of his first radio series, "The Linit Show," named for its laundry starch sponsor, have him offering a series of jokes and dialogues delivered in a style that is not just dry but stilted, an almost humorless drone. One wonders, despite his success on the vaudeville stage and in Broadway revues, why anyone would have thought Allen might succeed in radio, and how, after a season of this, he was asked to continue.

Soon Allen had changed his approach and was putting on a kind of loose, hour-long parody of a smalltown New England Saturday night entertainment, with touches of a town meeting, "Town Hall Tonight." He was quickly revealed as outstanding, at times brilliant, both as a writer and a performer. One secret was that Allen had discovered that he could relax and *ad lib* asides while on the air. With

that, what he was reading and what he was making up worked almost equally well, and his timing just about perfected itself. He could even laugh at his own jokes and have us share in his pleasure.

Another secret to his new success was revealed more gradually. Fred Allen had become fascinated with New York City and its people and its ways. "Town Hall Tonight" gave way to an hour-long "Fred Allen Show," and in sketch after sketch, he was able to make a huge national audience feel the same way about New York and its people as he did.

Allen's gags and skits abounded with regional and ethnic types, and they did so during the very time in our history when we were awakening to the offense often hidden in such burlesques. Yet few complained about Fred Allen. Admittedly, his tight-lipped New England farmer, Titus Moody, would be unlikely to offend. But there was actress Minerva Pious's array of Bronx Jewish housewife types, which eventually settled into the character of Mrs. Nussbaum ("You were expecting maybe Weinstein Churchill?" "Lauren Bagel?"*). In Ajax Cassidy's household, there always seems to be a noisy, possibly drunken, party in progress. Cassidy did draw some objections, it seems, but Allen, it may be worth noting, was himself Irish, born John Sullivan.

Allen did a sketch which involved a Mr. Katz ("I am managing director, mine host, at the continental joy spot in the Catskills, Chez Katz") and a Mr. Binns ("I'm operating the only Monte Carlo a stone's throw from Trenton: The Sea Gull Manner"). Each went after Allen's summer vacation business. Katz insisted that his place "is where Park Avenue is meeting the East Side" and Binns that "we gotta beat the epicures away from the dining room with a black-

*Mrs. Nussbaum's transformations of familiar names seems to have been based on an ethnic reality. A friend, the daughter of a New York rabbi, told me in the early 1950s that her mother would never miss (as that lady put it) "Arthur Gottleib" on radio or "Ed Solomon" on Sunday night TV.

jack." No one protested about the sketch; indeed, Katz and Binns were so well received that Allen brought them back on a later show. Fred Allen, the Boston Irishman, was somehow able to do the kind of humor Jews do about themselves and get away with it.

As far as I know, no Chinese Americans were offended by Allen's detective, Won Long Pan. The joke was not on them, but on the absurdities of the Charlie Chan movies, and in the case which involved a revolver hidden in a refrigerator, which came out "leewallawa in leeflidgelator," maybe Oriental Americans joined in the fun. Most revealing perhaps were Allen's opera and operetta spoofs. Singers from the Metropolitan were not only not offended, they asked to get on Allen's broadcasts to participate. Allen knew how to satirize with taste and without ridicule, how to satirize with respect but without compromise.

Fred Allen had a large and fairly vocal following among our writers. James Thurber and John Steinbeck, for examples, both praised and encouraged him, and the latter compared him to Mark Twain (a rather inappropriate comparison, I would say). And publishers begged him for book collections of his best scripts.

One might admire the skill of a Jack Benny, who created a fictional persona for himself and then made glorious fun of it. Or admire the skill of a Bob Hope as a monologuist, but know at the same time that his quips were usually ephemeral and his political wisecracks rather bland. Both Benny and Hope admittedly depended on a staff of writers. Allen wrote most of his own material himself, and closely supervised the rest. His social barbs had substance, yet his sharp anecdotes and sketches had a mass audience, an audience that a Thurber or an S. J. Perelman could never have. And again, the milieu of a typical Allen sketch was New York City and its types, mostly Irish and Jewish.

Allen was always alert to the value of a good gag or a well-used pun of course.

Announcer: Next week, Town Hall Tonight brings you
 drama!
Female Voice: Sir, do you think I'd die for you?
Male Voice: You gotta be a blond to get in this chorus,
 Toots.

But as I say, the substance of Allen's broadcasts was
satire. And Allen's was a satire that showed him carefully
walking the precarious line between buffoonery on one side
and bitterness on the other. A 1940 sketch usually called
"Hello, Folks!" had to do with the realization that the New
York World's Fair and its officials, with their morning
coats, striped pants, silk hats, and stilted ceremonies, had
been alienating potential customers. "We are de-swanking
the Fair. We are 'hello-folks'-ing it," the script had them
declare. But as Allen has it, New York citizen Balzac
McGhee slightly misconstrued the message. "Me and the
wife seen all that stuff in the papers . . . This ain't no
high hat fair. Come in and let your hair down." So Balzac,
Gert, and their little boy decided to "give this joy spot a
whoil."

Everybody is yelling "Hello, folks!" and "Make your-
self at home," at them. So Balzac and Gert are soon walking
around comfortably in their stocking feet, and young
McGhee without any clothes at all. At the dairy exhibit,
they milk one of the cows, and quell the guards' objections
by yelling and waving, "Hello, folks!" They eat a sizable
lunch from samples in the food building, make free long-
distance calls in the telephone exhibit, and "the kid is
swellin' up from free Coca-Cola." Again they shout "Hello
folks!" if anyone seems to object. Everything is going so well
that Gert suggests, "How about stayin' all night." They do.
"I'm sittin' by the Lagoon of Nations in me underwear,"
explains McGhee. "I'm readin' the paper by the light of
the fireworks. When anybody goes by, I'm yellin' 'Hello
folks!' Gert starts rinsin' out some stockings in the Aqua-

cade, and the kid's behind the perisphere doin' somethin'."*

Balzac, Gert, and the kid are arrested, and yelling out "Hello, folks!" won't quite work in night court where McGhee tries it on the judge.

> Allen: What did the judge say to you?
> McGhee: Thirty days.

Easily comparable to S. J. Perelman I would say, except that Allen is more likely to stick to his point, less likely than Perelman to veer off into the kind of hyperbolic silliness that perhaps only a Groucho Marx could get away with.

On another show, Allen introduced a news item which reported that a bunch of do-gooder art lovers had proposed that the bland ugliness of New York City subway stops could be relieved by adorning the walls with murals and reproductions of the old masters. Allen, in a memorable response to all this, interviews a Mr. Dodd whose great pleasure in life was adding mustaches to advertising posters and who didn't want anybody spoiling his fun. A Mrs. Tremayne who suggested that pictures of gondolas "gondoling" would be nice for the Canal Street stop. And a timid little man who only wanted to get to the Flatbush stop in Brooklyn was forced into a guided tour of the exhibits and repeatedly missed his train.

I think Allen's talent for satiric sketches, and his need to relax and ad lib when he wanted to, were better served by the hour-long shows he did between 1934 and 1940 than by the half-hour format he undertook in 1940 and kept until he left the air in 1949 (there was a brief return to hour shows in 1941). Allen partly yielded to a publisher's request for a

* At least the line went that way in Allen's script. On the air it came out "the kid is carvin' his initials on" The network "continuity acceptance" man (i.e., censor) no doubt intervened. Allen once said that such network figures, and particularly vice presidents, arrive at their desks in the morning to find a mole hill and their job is to make it into a mountain by the end of the day.

book collection of his best scripts with a collection of excerpts interspersed with comment, *Treadmill to Oblivion* (1954). The title was a reflection, perhaps, of a cynicism which overtook him in his later years. His show had been dropped in the face of competition from a massive give-away quiz "Stop the Music!" on another network. It is a good book, but Allen should be known to us for his complete sketches. And not by the written word, but by the way that word was brought to life on the air by Allen, Portland Hoffa, Teddy Bergman (Alan Reed), Minerva Pious, Charles Cantor, and the rest of the Mighty Allen Art Players. If we ever outgrow our attitude toward old radio shows as items of nostalgia and camp, and try to do justice to the best of them, surely a carefully selected anthology of Allen satire on audio cassettes will make its appearance. And take its place on our shelves along with the best American humor.

THE GOOKS HAD A WORD FOR IT

"Vic and Sade" began on network radio in 1932, acquired a sponsor (Procter and Gamble) two years later, and continued on the air for over a decade. It was an unlikely hit, but hit it was. It was perhaps an even less likely artistic success, but artistic success it was. It is one of two or three of the most durable shows to come out of radio and out of its time.

"Vic and Sade" was a daily, fifteen-minute comedy show, flanked on either side by the continued contrivances and continued agonies of daytime soap operas. It was confined to dialogue among three, later four, characters and was about nothing more than the mundane, day-to-day lives of a middle-aged, lower-middle-class couple in a small town in northern Illinois, Mr. and Mrs. Victor Gook, who are raising Russell (called Rush), the orphaned son of a relative of Sade's.

Vic's interests are mostly confined to his office job at Plant Number 14 of the Consolidated Kitchenware Company, and his lodge, the Drowsy Venus Chapter of the Sacred Stars of the Milky Way. Sade's horizons are largely limited to her kitchen, to gossiping by phone with her friend Ruthie Stembottom, to reading letters from relatives—particularly her sister Bess and, in the early shows, Uncle Fletcher—and to reporting on the exciting sales at Yambleton's Department Store, where a big item was usually a bargain on washrags.

Rush cared about ball games in Tatman's vacant lot with his friends Bluetooth Johnson, Rooster Davis, and Smelly Clark, cared about the adventure stories he read of Third Lieutenant Clinton Stanley, and, on one particularly delightful show, the new excitements of his first day in high school, where *every* subject meant going to a different classroom!

When the show began, it was confined to Vic and Sade. The device of Rush's adoption by the couple was used to introduce a needed third character into the dialogues. In a particularly funny and poignant 1932 episode, "Mr. Dempsey and Mr. Tunney Meet in a Cigar Store," Rush is awkwardly but lovingly accepted by the middle-aged couple as their own. Sade became "Mom" and Vic usually "Gov," and a string of awkward, affectionate nicknames were awarded to Rush by Vic over the years. But the tensions and ironies of a childless couple, already set in their ways, raising a son were never completely absent from the household.

Nor was the tension of Sade's inferiority of education and her outlook on life ever completely absent. Sade had only grade school, and her rather forced social giggles indicated not only her awareness of her lack of sophistication but a sense of humor that was limited at best. It was sometimes clear that Vic and Rush are discussing things or showing attitudes that she does not understand. But the

scripts never took advantage of her or treated her as an inferior, quite the contrary. A penetrating characterization of Sade and her ways was central to "Vic and Sade." If either Vic or Rush inadvertently reminded her of her limitations—and if they did it was always inadvertent—they were, we sense, as confused and upset about it as she.

"When you an' Fred have those flare-ups," Sade once said to Vic, "naturally the wife sticks with the husband. I noticed it tonight. I was peeved when Fred was laughin' at your work, and Ruthie was peeved when you were makin' fun of Fred's baseball players and his auto. We just couldn't *help* it. We *tried* to, but it was bound to show a little. Like I said, Ruthie is my best friend. My *very* best friend. I'm with other ladies a lot, yes—Mis' Donahue an' Mis' Harris an' Mis' Brighton an' Mis' Applerot—but it's not the same. Maybe it's because they're a little older than I am. Maybe it's because they're a little brighter in the head an' got more education. I don't know what it is. But I'm not the *same* with them as I am with Ruthie. With Ruthie I can laugh an' cry an' fight an' gossip an' get along just marvelous. With other ladies I sort of feel like here I am a woman that ain't a girl any longer an' got a fourteen-year-old boy to boot. See? . . . Ruthie and I get along a lot like *kids* get along."

Vic's response was a simple "um."

As I say, "Vic and Sade" was a public success, so much so that at one point it ran daily on both the NBC and CBS networks. The shows, if only as examples of Upper Midwest American accents, speech patterns, and attitudes—exaggerated though those things were—might delight a social historian or a philologist. But I am claiming for "Vic and Sade" a different kind of success. The scripts were acted by Bernadine Flynn as Sade, Art Van Harvey as Vic, and Billy Idelson, beginning as a pre-teen, as Rush. Their skills were much admired by their peers, so much so that rehearsals and other business would regularly suspend at NBC and CBS in New York and Los Angeles while actors,

directors, and writers listened to "Vic and Sade" on the air from Chicago.

The show's writer was Paul Rhymer, who seems to have been an exceptionally unpretentious man. As I have already indicated, he was fond of outlandish names and unafraid of using them. Some others included Dave and Cora Bucksaddle, Mr. Gumpox (the Gooks' garbage collector), the twins Robert and Slobbert Hink, J. K. Rubich (Vic's boss at the Kitchenware Company), Willie Gutstop—there were quite a lot of them. Rhymer was also not afraid of outright silliness: Vic was elected Grand Exalted Dipper of his lodge. The talk often turned to the latest news of Rishigan Fishigan of Sishigan, Michigan, who married Jane Bane of Pane, Maine. Still, Rhymer and his actors were absolutely committed to the reality of their characters. The show's billing as "radio's home folks" hints at a facile glorification of the ordinary that was avidly avoided in the execution. Everyone involved grasped the essential dignity of these characters and their individualities, as well as their petty absurdities. And although Flynn, Van Harvey, and Idelson reputedly had many moments when they found it hard to keep from laughing out loud on the air, the general tone of "Vic and Sade" was one of gentle comic whimsy, a whimsy which produced more smiles than laughs, a kind that was perfectly suited to the talents of all concerned.

In 1940 this fortuitous meeting of writer and actors was threatened when Van Harvey suffered a heart seizure. To cover, and to lighten Van Harvey's load when he returned to the show, Uncle Fletcher was introduced into the scripts in the person of a very young actor named Clarence Hartzell, and Hartzell complemented an already perfectly balanced ensemble with grace and ease.

From his letters to Sade read earlier in the series, one might have expected an interesting man in Uncle Fletcher, a man of far-flung friendships, perhaps even an informed traveler to outlandish realms, with many a romantic tale to

tell. Hartzell once remarked, however, that he saw Uncle
Fletcher as the kind of man who always wore both sus-
penders and a belt, and Uncle Fletcher proved to be perhaps
the dullest, most boring, humorless, absent-minded tri-
umph of a character that a writer could conceive and the
skill of an actor could portray—dull and boring to the others
with his endless, pointless stories, but of course never
boring to the audience.

There have been two book collections of Rhymer's
scripts, and off-the-air recorded versions of the show have
become treasures to collectors of old radio. That latter fact
indicates an irony and a frustration. The programs were
recorded regularly during their airings, but Procter and
Gamble later destroyed its collection of the transcriptions.
Therefore, any shows that do survive, survive almost by
chance.* And mind you, "Vic and Sade" was on the air five
days a week for over ten years, with no regular summer re-
runs. And yet, from among those shows that do survive on
recordings, particularly for the series' great period, from
1932 until Idelson left,** there is barely a poor one to be
heard.

It is easy enough to convey the quality of a good joke or
quip: one simply quotes it. It is less easy to convey the
quality of social or romantic comedy, but it can be done. It is
harder still, surely, to describe whimsical satire which is
also skillful enough to put a near-silliness to its own good
purposes, and a satire to which actors contribute so much as
Flynn, Van Harvey, Idelson, and Hartzell did. "Cleaning
the Attic" is one of the best scripts that has been published
and it is one of the best shows that we now have on audio

* Networks also regularly recorded and stored their shows in case of lawsuits.
These copies were sometimes secreted out of the NBC, CBS, and MBS archives,
copied and passed around. And particularly after 1938, when home disc recorders
were generally available, listener-fans began to record off the air as well.

** Idelson, whose Navy duty began in 1942, was at first stationed nearby and
was occasionally allowed to participate in the show during 1943.

tape. Sade is determined that Rush is going to help her clean up the attic on a warm summer morning before she'll let him do anything else. Rush complains about the heat and the dust. Rush trips over a mislaid popcorn popper (he had of course mislaid it). Rush calls down to the street below to a bewildered Bluetooth Johnson, who cannot figure out where the voice is coming from. Rush stops everything and sits down to give Sade his full attention every time she offers a plan of work or complaining comment. Rush has almost (but not quite) exasperated his mother to the point of giving up. Then Uncle Fletcher wanders into the house, calling out quaveringly to "Sadie," and seeking a morning visit. Rush responds, much to Sade's chagrin, that the two of them are in the attic and to come on up. Sade, as she now gets even more insistent that the job has to be done, must be sensing that the end of her best-laid plan is in sight. But she fights on, trying to ignore Fletcher's pointless ramblings about old friends he insists had been her friends (but whom she has never heard of), while Rush again stops everything to sit down and listen politely to his uncle's meandering, heedless, guileless talk, implying of course that anything else would be rudeness to his elders.

And finally, Uncle Fletcher, perhaps at last sensing Sade's exasperation, manages to fall off the trunk he was sitting on ("It's slippery," he insists. "I slid off.")

Sade: I give up, Rush.

Rush: Huh?

Sade: I give up.

Rush: You mean . . . ?

Sade: We're goin' downstairs.

Rush: Oh?

Sade: Come on, Uncle Fletcher. We're *all* goin' downstairs.

Fletcher: Attic looks much better now that you've cleaned it up.

Sade: [*dryly*] Yes, doesn't it?

Fletcher: Rush makes a nice helper for ya.

Also, from among other surviving shows there is Sade's long, excited account of the bargains and social goings-on during a "Sale at Yambleton's." She was there to marvel at the low prices and see all her friends. She bought nothing, and she couldn't understand Vic and Rush's surprise that she hadn't. There is "A Letter to Walter," in which Sade insists that Vic write a chatty message to her sister Bess's husband—after all, Vic spends all day writing letters for the Consolidated Kitchenware Company, and Bess and Walter know what a "monstrous big important" job he has. Vic's attitude is that he really has nothing to say to Walter; they have nothing in common. "Only that you married sisters, is all," says Sade, believing she is making her point but of course only underlining Vic's. Rush gets into the argument and tosses off a sample letter that is rather like a spoof on one of Bess's. Vic finally copies off an article from the local paper, hoping to get away with the ruse. Sade goes off to bed with her feelings hurt, leaving Vic and Rush almost equally hurt and confused. Probably no show more touchingly reveals the basic sympathy of author and actors toward the objects of their humor.

Finally, there is a poignant summer evening conversation on the front porch between Sade and Rush, as the neighbors return from work and begin to hurry along as a thunderstorm gathers. Sade's comments, and Rush's comments and questions, reveal a whole comic townful of people, who were never heard on mike, but brought to life by the writer and his actors.

I admit I may be leaving most readers with only the two published collections of "Vic and Sade" scripts to turn to. And the challenge perhaps to seek out the few relatively obscure dealers who offer cassette tapes to collectors of old radio shows (and with such dealers one must pick and choose and seek rather blindly for the right shows from

listings in catalogues). Perhaps my final word is again to the producers of audio tapes, books-on-tape, and the like: collect and make available "Cleaning the Attic," "A Letter to Walter," "Sale at Yambleton's," and "The Thunderstorm" on a 60-minute cassette. You will add a treasure to the shelf of regional American comic literature, as well as evidence of how good radio could be in the 1930s. Surely in an age of growing electronic communication you could do no less for our country's culture.

The Small House Halfway Up in the Next Block (McGraw-Hill, 1972), edited by Paul Rhymer's widow, Mary Frances Rhymer, collects 30 scripts including the touching early episode which established Rush in the Gook household as well "Rush's First Day at High School."

Vic and Sade: The Best Radio Plays of Paul Rhymer (Seabury Press, 1976), also edited by Mrs. Rhymer, adds 30 more scripts, including "Cleaning the Attic."

ON THE AIR
WITH PICTURES

A PURPLE DOG, A FLYING SQUIRREL, AND THE ART OF TELEVISION

What we hear on television is more important than what we see on the small screen; in television at its most effective, and in contrast to movies, what we hear is primary, what we see secondary. But the visual images should underline, enforce, complement, and integrate with what we hear.

The preceding is not an abstract hypothesis but my effort to describe what I observed on a fine television achievement: a group of delightful shows designed for children, at their best unique comic experiences. They were "Huckleberry Hound," and its offshoots "Quick Draw McGraw" and "Yogi Bear," and another and better series, at first called "Rocky and His Friends" and later "The Bullwinkle Show." All of them were cartoon shows produced especially for television, and they showed a unique, well-realized television style.

I first came upon these unpretentious little programs with a kind of awe, even before fine comedy impressed me. The TV set seemed bursting with an artistic energy and purpose. It was almost like watching D. W. Griffith's *The Musketeers of Pig Alley* or a good Mack Sennett chase sequence for the first time, and being almost overpowered with the expressive possibilities they uncovered. These TV cartoons would seem so good nowhere else. Project them on a theater screen and, it seemed to me, they would pall; on television they were fully effective.

Economists would have a fine time rationalizing this effectiveness in their terms. TV cartoons are turned out fast and cheap, and conventional animation techniques take time and money. But I think the real reason is that to creative people any limitations can represent a kind of artistic challenge. Pantomime, camera, settings, and titles, these were what Griffith and Sennett had to work with. If they had had sound, precise lighting and other technical refinements they might have learned to express far less.

Cartoons, old movie cartoons, have been a staple of TV since its beginnings. By the early 1950s a few cartoons were being produced especially for TV. Technically and aesthetically, they were crude, almost a succession of still pictures with a bit of movement. The voices and scripts carried the show. Soon original cartooning for TV was commonplace; some of the results were good, some terrible; some still didn't move much. But, as I say, the best discovered the medium.

The drawings in "Rocky" and "Huckleberry Hound" had to be simple and functional, the backgrounds fairly plain and stylized, the movements few and direct. Complex and difficult actions often happened off-camera and were conveyed by crashes and yells. The little animals walked and gestured stiffly, and if the artists were perceptive enough, they made these stylized movements amusing also. About one thing the animators were very careful: the right

lip movements for the speeches. The creative core of these
shows lay first in the writing, then in the highly resourceful
people who did the voices, not to mention the sound effects.
And I expect that TV drama can be a writer's and an actor's
medium in the sense that movie drama is ideally a director's,
although people who work in television insist that it is the
producer who is really in charge. Accordingly, wild comic
liberties can be taken with space and time—if an animated
cat has a long, funny speech to make while running across a
yard, the trip and the length of the yard are simply expanded
to accommodate the speech. Always, the drawing needs to
keep its place, and fulfill its place.

The "Huckleberry Hound" shows were produced by
William Hanna and Joseph Barbera, who used to do "Tom
and Jerry" theater cartoons at MGM. Their style then owed
a great deal to the wonderful cartoons made at Warner
Brothers—Bugs Bunny, Daffy Duck, Tweety and Sylves-
ter, etc.—surely some of the best American comedy ever
done. The "Huckleberry" cartoons profited by such experi-
ence and such skill, but they transmuted previous anima-
tion styles to the new limitations and purposes of TV.

All the voices on "Huckleberry Hound," "Quick Draw
McGraw," and "Yogi Bear" (and each show was made up of
three segments with three sets of characters in each) were
done by the late Daws Butler and Don Messick. They often
used the time-honored cartoon practice of borrowing and
adapting well-known manners of speech. Yogi Bear, for
example, sounded quite a bit like Art Carney's Ed Norton.

I should attempt some description of these shows and
their characters and I think a random one will be best.

Quick Draw McGraw, for one, was a horse, a parody
Western hero, and he had a Mexican-accented sidekick
named Baba Looie. On his show, there was also a segment
devoted to Snooper Cat, a trench-coated parody private-eye
who talked with the malapropisms of Ed Gardner on the old
"Duffy's Tavern" radio show. There were Augie Doggie

and Doggie Daddy. Doggie Daddy talked a lot like Jimmy
Durante and was constantly amused and ultimately cha-
grined by Augie's befriending and communicating with an
assortment of bugs, ants, mosquitoes, other animals, and
even Martians.

One sequence went more or less like this: Augie and
Daddy were driving along. "Thank you, dear old Dad, for
taking me on this picnic," piped Augie. "Dat's OK, my son,
my son," graveled dear old Dad. They passed a small duck
standing by the roadside with his thumb out who patiently
explained to the camera in a Donald-ish quacking, "All the
other ducks have flown south for the winter, but I can't fly
yet because I'm too small and puny. So I'm trying to get
there by hitch-hiking."

Then, "Oh stalwart father of mine," said Augie,
"there is a small duck beside the road seeking a lift."

"If there's one thing I can't stand," gruffed Doggie
Daddy, "it's a hitchhikin' duck."

Later, when he and Augie were trying to get extra
rations from "generous, kindly old Dad," the duck an-
nounced, "Did you ever see a pitiful little duck stagger and
faint from lack of food? Watch this!" as he ostentatiously
staggered, spun, twirled, gasped, and finally fell.

Variously, we also met Mr. Jinx, a cat, a sort of
confused, beatnik Marlon Brando who, like, chased Pixie
and Dixie, two mice from down South. There was Snag-
glepuss, an enthusiastic lion who talked like Bert Lahr, read
his own stage directions ("Exit, guileless as ever, stage
left!"), and acted out all the fantasies he could uncover: "I
am merry Robin Hood, come a-robbin' of the rich!" he
answered to a policeman's annoyed "What are you, some
kinda nut or somethin'?"

"Rocky and His Friends" was in some ways a more
sophisticated affair, and it had none of the deliberate
cuteness sometimes found on the "Huckleberry" shows. It
abounded in lampoon, burlesque, and wild puns. The basic

stylization and simplicity in movements were there, but the drawing was less like movie cartooning and more like contemporary comic illustration, even an occasional BANG! HELP! was lettered on the screen. The scripts were written and the designs and layouts made in Hollywood, and for economy the animation was executed in Mexico. There was a remarkable integration between the scripts and designs, and Rocky also had some of the most rewarding visual delights on TV, particularly a stock pattern which closed each episode and showed Rocky the Flying Squirrel and his friend Bullwinkle the Moose suddenly and surrealistically sprouting up, blank-faced, in a sunflower under a burning sun.

Along with engagingly befuddled Bullwinkle, Rocky was, as the narrator William Conrad explained in edgy tones that parodied half a dozen TV newsmen, "that jet age aerial ace, Rocket J. Squirrel," the cheerfully innocent hero of a serial lampoon. Rocky and Bullwinkle's antagonists were Boris Badinov ("Hello there, fans of spying and sabotage!") and his bomb-throwing accomplice, sloe-eyed Natasha Fatale. Boris, supposedly a master of disguises, might appear as pilot Ace Rickenboris, Baby Face Braunschweiger ("America's favorite gangster" and leader of the Light-fingered Five Minus Two), or as Lord Chumley (with a heavily Slavic "Top hole, old bean. What ho!"). If he got stuck, Boris could consult his *Pocket Book of Fiendish Plans* or speak with "Fearless Leader" by short wave. Or if he really goofed, he'd get a visit from a shadowy "Mr. Big."

The "friends" of Rocky were "Fractured Fairy Tales" narrated with fine officiousness by Edward Everett Horton, or "Aesop and Son" told with eager innocence by Charlie Ruggles. Since I have an almost touchy respect for the wisdom of traditional lore, I hasten to say that the fairy tales were "fractured" on the Rocky show with a kind of loving respect, and lampooned without ridicule—even though every magic fish turned out to be a smelly, week-old carcass;

every dwarf magician and tempter of the hero had the air of a fast-talking Bilko-esque press agent about him; and gnarled old witches were apt to sound remarkably like Marjorie Main and call everybody "dearie."

Then there were the adventures of "Mr. Peabody and Sherman." Peabody was by his own admission, brilliant. He was a dog who has adopted a small boy, Sherman. Since he kept Sherman in a big city apartment, he had trouble amusing him and invented a time machine, the Wa-bac, to keep him occupied. Through the Wa-bac, Mr. Peabody, with Sherman cheerfully tagging along, was able to help a Chico Marx-accented Signor Borgia find an antidote for Lucrezia's arsenic-laden cacciatore; a confused and meandering Balboa to find the Pacific Ocean; a highly disinterested Fulton get his steamboat under way; and a slangy Sitting Bull get to Little Big Horn in return for an autographed picture of Tonto.

"Rocky and His Friends" and "The Bullwinkle Show" were produced by Jay Ward. Bill Scott was the chief writer, and the voices were done mostly by Scott, the aforementioned William Conrad, June Foray, Paul Frees, Walter Tetley, and the ubiquitous Daws Butler.

I could add a word about "Roger Ramjet," a 1965 cartoon series which spoofed such traditional radio-TV kiddy adventure shows as "Jack Armstrong" and "Sky King." Roger—square, rather pompous, and none-too-bright—led Yank, Doodle, Dan, and Dee ("Ramjet and that bunch of rotten kids," a villain once called them in the voice of a deranged Burt Lancaster) in a never-ending battle against the sinister forces of evil. The animation was bareminimal, and some outrageous anti-cinematic jokes were played with it: talking profiles were "flopped" (reversed) in the middle of speeches; the same shots were amiably cycled and re-cycled, sometimes in the same episode. Again, the scripts and voices carried it all, and the writers seemed to have been having a wonderful time. One segment made

constant (but sanitized) allusions to the punch-lines of several standard dirty jokes. Another had a time machine plunk Roger down in Renaissance Florence in his jet togs. Seeking directions, he knocked on a door marked "Leonardo, Painter," to be greeted by an ebullient, "Eh, keed, a-come on in! You wearing a funny suit, you look like a swinger!" Then "Go home, sweetheart!" he adds to his female subject, who of course looks quite like Mona Lisa. "I paint-a your pitcha tomorrow." Well, in any case, a cartoon series with very little animation turned out to be most enjoyable, and, as television, fully expressive.

I am told that both "Rocky" and "Huckleberry Hound" are still re-running on cable outlets and they are available in carelessly edited compilations on VHS. And "Roger Ramjet" is similarly available on home video. It is hard to believe that Hanna and Barbera very soon spread it so thin as to produce the derivative, noisy "Flintstones" show, and have done even less interesting shows since. In any case, the point is not more cartoon shows, but the marvelous, unpretentious aesthetic language and style certain cartoon shows achieved.

TELL ME A STORY

Television, by a layman's rule of thumb, is a system by which pictures as well as sound may be broadcast. Television was at least theoretically possible in the minds of the early developers of radio. It was a fact by the early twenties. And it has been commonplace since the late forties.

Its early enthusiasts announced that it was possible by means of TV to bring one expert teacher to hundreds of classrooms and thousands of students. Used in the home, it might bring literacy to the adult illiterate. It could bring some history and a great deal of contemporary reality into

the homes of the more sophisticated. In short, it could be a boon to education, formal and informal. Such ideas about what man might do with TV were probably inevitable. The same sort of thing was no doubt said about the printing press. Within living memory, the same sort of thing was said about the motion picture and about radio.

Perhaps it does not really matter how anyone thinks television ought to be used. What does matter is how television is being used. And man has used television primarily in the same way he used the printing press, the movies, and radio—to tell himself stories, stories which purport to reflect his own condition and aspirations. And from one point of view, telling himself stories is man's most profoundly educational activity.

Those who contend that TV should be used pedagogically offer an approach which seems also to favor traditional culture. TV is an ideal medium for the presentation of traditional and contemporary drama, which of course means drama originally created for the stage. Nothing is more prestigious for TV than to present a "special" which will pass for "serious drama." But any critical viewer of Sophocles or Shakespeare or even Tennessee Williams on TV must surely become aware that it is nearly as difficult to translate effective stage drama into effective television as it is to translate it into effective film drama. Setting up cameras in front of a classic play or an acclaimed Broadway hit won't work. And it may even put limitations on television's own potential as a creative dramatic medium.

Historically, the first drama presented on television was a specially written play called *The Queen's Messenger,* broadcast experimentally on September 11, 1928. Its method of presentation was prophetic: three immobile cameras were used, each assigned to an actor photographed in close-up, and the resultant broadcast was a cross-cutting of these three faces as they exchanged dialogue. In short, the technique amounted to a kind of photographed radio. And

with important modifications, that is what television technique has remained ever since.

Understandably, Hollywood cameramen filming for TV dislike the style, "just a bunch of tight close-ups and two-shots of people talking to each other." TV drama is not "just" that, but it very nearly is. Why, one wonders, does such a style persist despite the best intentions of actors, writers, directors, and cameramen who have worked in theatrical films, and who would like to present a more specifically cinematic style on television? Why does the style persist even as TV screens grow larger (and as our movie screens grow smaller)? The conclusion seems inescapable that, at its most effective, television is not, and cannot be made, a primarily visual medium.

Received opinion has it that TV drama found its best expression in the early, post-World War II days of the "live" New York dramas on "Studio One," "Kraft Theatre," "Schlitz Playhouse," "Philco Playhouse," and the rest. Indeed, this period, ending in the mid-fifties, has been referred to as a "golden age" of achievement for American TV, an era before mass-produced mediocrity set in. But it seems to me it is a mistake to attribute profundity to a capably written and performed naturalistic playlet like Paddy Chayevsky's *Marty,* in which a young Bronx butcher breaks away from the pressures of his family and friends long enough to marry a mother-surrogate schoolteacher. Or to attribute a devastating criticism of big business and its wheeler-dealers and philistines to Rod Serling's *Patterns.*

Perhaps I am being unfair to a historically important period of TV drama. Or perhaps my criticisms are aimed not so much at those who wrote and produced the hour-long, New York-based dramatic shows as at the commentators who have championed the period as a golden age. Undeniably there were several good plays—Reginald Rose's *Twelve Angry Men* seems to me a quite good play. But the most significant contribution of live New York TV drama was, I

think, no individual play, however good it may have been. The major influence on the playwrights, directors, and actors who participated in this era of television was the Broadway stage, particularly the "serious" Broadway of the thirties, of Sidney Kingsley, Clifford Odets, Maxwell Anderson, William Saroyan, and more contemporary Broadway manifestations of that tradition like Arthur Miller and William Inge.

The outlooks and attitudes of these young TV playwrights, the style and content of their dramas, were by and large those of the New York stage of the time. The TV critics of the time were largely committed to the same attitudes and the same modes of drama, and the majority of set owners at the time were Northeast and urban. The somewhat haphazard and physically confining techniques used to present those dramas, a handful of studio sets, were perhaps too limited and stage-bound for the dramatic potential of TV.

Still, the contribution of this period lay precisely in the fact that it leaned on the stage for its inspiration. Theater is a verbal medium. So is television, and these shows, if they did not discover that fact, at least underlined it. Television, however, is capable of a great deal more physical mobility and flexibility, and it calls for a great deal more dramatic terseness and condensation than a heavily stage-influenced style can offer. Television was to discover that it needed film, not to imitate the movies (but certainly to learn from them), and not (as with the movies) because film can be cheaply duplicated and hence widely distributed—one or two prints of a filmed television drama are quite enough to reach millions—but because film offered a controlled mobility and quick flexibility of dramatic image which would prove effective on TV. Film can get around. And film can be edited.

Television can make heavy demands on its actors. On the stage, a performer knows that whatever he does must be

broad enough to reach the top of the second balcony if there is one. In movies, the camera is only a few feet away. But the audience is spread out to the rear of the house, and acting needs to respond to that fact. On television not only is the camera six feet away, so is the audience. TV acting has been described as only a set of techniques, but at its best it is much more than that. A television actor needs to be especially intimate, easy, unforced, and unpretentious; needs to know where the camera is and where the audience sits; to know that in order to play it as close and as casual as TV demands, the actor must play his character as close to himself or a part of himself as he possibly can.

Television's often maligned "short attention span" is not some sort of capricious impatience imposed from the outside, but a part of the nature of the medium itself. As any writer who has worked for both the stage and the movies can attest, film calls for terser, tighter dialogue and briefer scenes than theater. Television, to be truly effective, needs greater condensation still, and even shorter scenes. All of which puts great demands—and I think critically unacknowledged demands—on its actors. An actress may need to go from deep affection to disgust, an actor from eager curiosity to indifference, in scenes which last less than a minute, and be convincing about it.

A TV critic once remarked that perhaps a quarter of the shows presented on television are worth watching. And a successful TV producer once said, with unusual candor, that he feels satisfied if ten shows out of thirty in a given series are really good ones, a figure only slightly higher than the critic's. Both estimates seem quite generous to me. What grand conclusions we might reach about the state of American literature if we decided that one-quarter of all novels written in a given year were actually worth reading! Indeed, if one were forced to read only half of the "best" novels published in a year, he might easily conclude that the

state of American letters should be described as a vast
wasteland.

Probably most members of the TV audience—
regardless of the height of their brows, the level of their
intelligence, or the extent of their education—would con-
cede that "most" television is poor. And why should anyone
expect the situation to be otherwise? We take it as a matter
of statistical inevitability, if not a matter of aesthetic fact,
that most novels will not be very good, and the same with
most poems, most essays, most short stories, most plays,
most music, most criticism. But if most of television is poor,
we seem to feel something can be done about it if we hold an
outraged congressional investigation, or bring it up at the
national PTA convention, or perhaps sniff around sus-
piciously for some sort of conspiracy.

The question is not that most of us would consider
most television boring—or at least that question does not
seem to me a very fruitful one. It might be more interesting
to ask why such and such a show, regardless of critical
opinion of its quality, has a hold on the public. But it would
be fruitful to ask how many really good shows there are or
have ever been on TV, and ask whether they reflect tech-
niques, qualities, and attitudes one does not find in other
dramatic media.

It has been said that television is not really a medium of
drama but a medium of advertising. And more than one
commentator has pointed to the disproportionate amount of
time and money spent in the production of TV commercials
as opposed to the production of TV shows themselves. If we
assume that time and money constitute some criteria for
judgment (a dubious assumption, to say the least), is not the
same sort of thing true of our magazines and newspapers?
Juxtapose advertising with almost any activity, and adver-
tising would probably prove to involve more time and more
money. TV commercials also must bear the brunt of criti-

cism simply by the nature of the medium: they are offered in time rather than in space. In reading a magazine, if we do not care what Virginform has to offer in its new line of padded bras, we can center our attention on the opposite page and pursue an article on the fallacies of academic testing. In TV we either attend what's in front of us or we turn off the set.

What attitudes do please a TV audience? Are they the same attitudes that please the audience that still pays to go to the movies or that reads mass fiction? My question may be unanswerable. The audience for "Dallas," let us say, and the audience for "Cheers" may be very different audiences, just as the audience for "bodice ripper" novels is probably not that of Joyce Carol Oates.

Let us take a plot: a young husband and his pregnant wife desperately need money. Fate tempts the husband with a situation in which it seems he can steal something and get away with it. However, he is discovered and in an ensuing scuffle he believes he has killed a man. He flees, confesses to his wife, and they become fugitives. They are pursued, overtaken, and the truth is revealed.

Such a plot might be treated in any number of ways. The emphasis might be on the circumstances of the chase, the capture of the husband, and happy revelation that he is not a murderer. At a slightly more sophisticated level, there might be a note of irony: the husband is captured because he slowed down his flight in an effort to protect his pregnant wife.

On contemporary television, such a plot would probably be given a different focus. We would not be asked to attach our interest to a complicated chase and capture, or to pin our hopes on a happy ending. On TV, the drama might easily focus on the psychology of the fugitives and their relationship: the effect on the young man's character of the fact that he had become a thief and thinks he has killed someone; the effect on the wife as she realizes that she had

married a man who has become a thief, a killer, a fugitive, and has made her a fugitive too. Anyone who has watched very much TV drama will know that it is possible for a regularly scheduled TV "series" show, not a prestigiously aimed "special," to treat this plot as a conflict of character. And it seems to me that it is a singular development in American popular drama that such a treatment might appear on TV.

As I say, when we theorize about television, we will usually say that it fails us because it does not bring us education, enlightenment, and a knowledge of the theatrical and musical classics, as it might. And we are apt also to say that TV has brought about a corruption of taste, a decline in literacy, and an increase in violence and promiscuity in our young people. Within my own memory, the same sort of things were said about the movies and about radio—that admission comes from someone who regularly did his algebra homework while listening to Fred Allen and to Orson Welles and the Mercury Theater of the Air. My father was told much the same thing about the "dime novels" of his youth. And as I have said, the same sort of thing must have been said about the printing press. After all, in the English language, early publishing went to Malory's retellings of the Arthurian Romances and not only to the lives of the saints and martyrs.

On the matter of violence on television, one should first observe, surely, that there is far more gratuitous violence in current movies and current fiction than there is on television. Some of the violence on television is extreme, gratuitous, and aesthetically extrinsic. It is piously denounced, but to what end? In the name of protecting children from violence, and under the assumption that they should be so protected, we have produced some curious hypocrisies. On Saturday morning TV, Captain Right may pick up two youngsters by the scruff of their necks and tell

them in a rich baritone voice that they should stop fighting and settle their differences amicably. And the unspoken next line surely is, "Because if you don't, I'm gonna beat the heck out of both of you!"*

Some years back, there was a television reviewer who alternately filled his columns with complaints about TV's lack of attention to classic plays, operas, and the like, and complaints about television violence and sex. I was tempted to write to him more or less along these lines:

> Dear _____:
>
> I've been reading a lot of stuff in the papers lately about violence and sex on TV, and I know you're concerned about it. Some say it hurts our kids and some say it doesn't. Well, you don't have to ask me twice about it.
>
> Like this one show I saw last year, right in my own living room, mind you. When it started out, there had already been one murder, and the hero (if that's what you'd call him) was seeing things, having hallucinations, and thinking about committing another killing. The next thing you know, he's in his own mother's bedroom, and the way they were looking at each other and talking, well, it didn't leave a lot to your imagination about what was on their minds.
>
> The "hero" also had this girlfriend. He was supposed to like her a lot but he sure treated her something terrible. He insulted her and called her dirty names. He even insulted her father. Then he ups and stabs the old boy,

*There have been tests set up to try to discover the effects of violence on children, of course, and I must say that I find most of them singularly unconvincing. A boy of ten is put in a room with a TV set and two chairs, one for himself and one for a life-size dummy. The TV set shows one man beating up another man with his fists. The boy is soon observed beating up on the dummy. Proving, it is said, that TV encourages violence in kids. Let us say that a girl of ten is put in a room with a TV set, two chairs, and a doll. The set shows a mother cuddling an infant. What might one expect the girl of ten to do? And what would that prove about television? (*Pace* all members of N.O.W.!) Precisely nothing, I would say in both cases.



claiming it was an accident (but not seeming to care much about it), and he dragged the body around by the foot. (I'm telling you the truth!)

The next thing you know the poor girlfriend has gone crazy (small wonder!). Then she died, and when they were trying to bury her—now get this—the "hero" jumped into her grave and tried to make love to her corpse before they pulled him off of her.

There's not much point in my going on with this stuff, but this show ended with sword fights, stabbings, and poisonings until practically everybody was laying around dead. At that point, someone had the nerve to wish the hero "Good night, sweet prince."

So you don't have to ask me twice about what TV is doing to our young people these days with this sort of thing coming into the American home.

Yours truly,

Thinking it over, these several years later, I wondered if my real point was that an exclusively elitist tradition could never have produced a *Hamlet*. But that a *Hamlet* could never have come out of an exclusively popular tradition either.

The question of violence in the arts is usually looked at in two ways. One says that it should not be there because it encourages a real violence in others, particularly in the young, the impressionable, and the insecure.

The other holds that an eruption of violence in drama is evidence of a strong temptation to violence in each of us, like a warning dream that something is welling up that needs to be dealt with. That same attitude might add that in very good drama, one's propensity for violence can be purged in the act of witnessing the drama itself and identifying with its characters. Those two attitudes, recognizable as Platonic on the one hand and Aristotelian on the other, have provided Western civilization with one of its fundamental

and unresolved contradictions. We should not expect that
contradiction either to be resolved or to be simply accepted
as a human paradox through the presence of television. In
any case, in helping us come to terms with some of our most
recent violence, television has given us, for example, *Roots*
and *The Holocaust,* so I wonder what apologies it owes to
anyone.

Television, a medium which rescued the foundering
careers of Lucille Ball, Jackie Gleason, and Red Skelton
(they seemed almost to have been waiting for television so
that they could find their real talents), which has given us
(at random) "Naked City," Carol Burnett, the "Mary Tyler
Moore Show," "M.A.S.H.," and "Cheers," probably needs
to make no apologies at all. American television, finding its
own way like the movies before it, finding its own expressive
resources, and its own means, has produced a small share of
drama and comedy unique in quality and outlook, a small
share that might be a source of satisfaction—perhaps even a
cause for celebration.

Several home video collections of Rocky and Bullwinkle are available
 from Buena Vista. The Huckleberry Hound, Augie Doggie VHS
 collections seem poorly selected and programmed.
Any reader who is intrigued by ideas in the preceding two chapters on
 television may want to consult my book *TV: The Casual Art*
 (Oxford University Press, 1982).

Music on the Tube

Music presented for its own sake has never been very successful on television. And the problems of offering music on TV are not simply a matter of TV's huge audience, not of the taste and previous musical experience of that audience, nor of the potential interest among viewers for a given style, tradition, or genre of music.

In putting music on TV, one is asking that an audience sit and watch attentively while cameras observe people making music, and while microphones pick up its sounds. And for whatever reasons, like it or not, few programs have ever succeeded in doing that effectively. Not on TV. And not on film. And none have done it on a regular basis.

In the late 1930s a couple of American movie studios conscientiously presented a few 10-minute short subjects in which competent symphony orchestras, usually the film studios, own staff musicians, sometimes under well-known conductors, performed short "classics." And to even the

most committed and interested members of their audiences, these shorts quickly became boring.

Comparable musical interludes were introduced into feature films in the 1930s and 1940s—by celebrated instrumentalists and singers, symphonies with renowned conductors, good jazz groups, and less well-defined dance bands. In almost every case, the cameras and the successive visuals moved around, seeming to watch, but actually fidgeting badly. Then cut-aways were introduced, not only to other actions but even to other sounds and to exchanges of dialogue, superimposed on the music and musicians.

I had best acknowledge that a few exceptions do exist, where extremely sensitive directors, cameramen, and film editors managed to observe musical performance "from the inside," as it were, and captured the feel of performance or the ambience of the concert situation. (Allan Miller's short film of Zubin Mehta conducting Ravel's *Bolero* is much admired.) But such accomplishments are the exception rather than the rule and, as I say, depend on exceptionally sensitive team work among director, cameraman, and film editor. It is true that song can work on television, but by that I mean only the brief performance by a pop singer or group as a part of a "variety show" context. (The longevity of the Lawrence Welk show on TV was a phenomenon that rather defies my understanding, so I have decided to leave it out of the discussion.)

Are we faced with a problem similar to that of presenting "classic" drama on TV? We have learned (to our grief perhaps) that simply setting up cameras in front of even the greatest performance of *Hamlet* or *An Enemy of the People* simply will not do. It took the sound film nearly twenty years for Laurence Olivier, in *Henry V,* to find a way to make Shakespeare effective on film, and not all who have followed him have succeeded so well. Perhaps it will take longer to make Beethoven effective on film, or to make Sonny Rollins come across well on TV.

Still, the practical truth is that what works best on television is what is delivered in short segments, with constant (although sometimes only apparent) changes of subject and setting. Whether one would like it to be so or not—and without worrying too much about why it is so—it is so. Commercial TV discovered that truth some time ago. Even hour-long TV drama comes in four acts, each of which is about twelve to fourteen minutes long and, within these acts, there are always several short scenes and changes of setting. "Sesame Street" has adapted itself to it superbly, as has the "MacNeil/Lehrer Newshour," and the "Laugh In" show exploited it to the point of parody of the medium itself.

The question becomes: how might one take advantage of this nature of effective TV programming in offering good music on the tube, in such a way that an audience will want to watch and listen attentively and enjoy it?

I will offer my ideas largely based first on jazz performances but with the understanding that the same principle and approaches would work for any music on the tube.

First, on TV, no piece of music can be performed that is over nine or so minutes long, and most pieces should be less than five minutes. Anything longer, masterpiece or not, simply cannot be performed on the tube, and will have to be saved for another setting.

Second, at least in the beginning, music programs on TV should be confined to half-hours.

Third, each show must be made up of several distinct segments, not just several musical selections, and each segment offer different music by different performers in different settings.

Fourth, no group or soloist or singer can appear on any given show more than twice—and never successively.

Very well, let us for now (shamelessly) call our series "Music Row."

Along "Music Row," a guide or master of ceremonies can lead us from one stop to the next and offer brief

introductions to the music heard at each stop. First, he
might invite us to drop in at the street's small night club.
Then at its rehearsal hall. Then at its small concert hall.
Then at its recording studios. And then at a conservatory
classroom. We enter each and hear a piece of music. Then
we re-enter the street and move to another stop and another
piece of music.

Let's be practical for a moment. Let's assume we are
going to do the usual series of thirteen shows. Following
standard TV tape editing procedures, we would hire thir-
teen groups, including a range of styles and instrumenta-
tions, but including at least two solo pianists and at least
three singers. Each group is shot separately performing
several pieces, in one or two possible settings (except for the
classroom, and we'll get to that later). As indicated, by
reassembling the footage we have already shot, a show
would take us on a stroll down "Music Row," dropping in at
the night club to see what Horace Silver is doing; at the
concert hall to see what the jazz repertory orchestra is
rehearsing; the small rehearsal hall to see what Carmen
McRae is working on; etc.

Each piece by each group must of course be carefully
observed by the cameras and the "switching" so as to bring
out the quality of the music (there will need to have been
previous camera rehearsals). The sound must be handled
with special care.

A complete show, therefore, would offer four or five
groups of people making four to six pieces of music from
different locations along our fantasy street.

And in the conservatory classroom? There we will
offer, in segments of probably never more than two min-
utes, and never more than one segment per show, brief
educational, instructional, and personal points. These will
work best if they are edited from dialogues between teacher
or visiting artist and a student or groups of students—
explaining the blues form; commenting on the jazz vibrato;

on how a jazzman might "swing" and embellish a familiar standard song, starting with the sheet music; on the musical life; or comments by some of the artists on themselves and their work.

To continue with jazz for a moment, there are three or four basic musical constructions in introducing jazz to listening audiences: jazz rhythms; the blues form (our only original musical *form*); the various jazz variations—based not on the original melody but only on its harmony; jazz composition (why does a music that so often borrows its vehicles from the popular repertory, and makes up 40 percent of what it does, need composers?); the evolution of jazz styles.

Then there are matters like the integrity of the idiom and its players; their search for instrumental perfection; their audiences and the places they play; their own lives, and the enormous (often oblique) influence that they have on other music and musicians. I believe that all of these issues should be handled within the format suggested above.

Later one might consider making "Music Row" a bit more informative. A "practice room" setting could be used for slightly longer segments and for more than one per show. The music should reflect the points made in these sessions, and the narrator should briefly point out those relation-ships.

The general presentation of other music would be much the same: short works or movements of long works, most under five minutes and nothing longer than nine. Use several, preferably small, ensembles in a range of instru-mental styles: baroque, classic, romantic, impressionist, contemporary; some star soloists, a baroque singer or group of singers; and a singer specializing in nineteenth-century opera and lieder. The several settings can be much the same except that instead of the night club, substitute a drawing room with more or less late eighteenth- or early nineteenth-

century decor. The conservatory talks and "lessons" could be similarly used—words on sonata form as used in two of the works played; on the best finger positions for playing Mozart as opposed to Debussy; how I feel about music; etc.

Assuming that our thirteen weeks of jazz styles and thirteen weeks of a variety of chamber music go well, certain future possibilities would present themselves. As a setting, a church or a chapel could allow for the introduction of solo organ works and choral music. With slight variations in the settings, American "country" music styles could be used.

And the final step: several musical styles and traditions in the same program, jazz, "classical," blues, bluegrass, a gospel ensemble, a chorale—some or all on the same program. Three kinds of polyphony, let us say, New Orleans jazz, Bach, and bluegrass. Two kinds of sacred music, a portion of a baroque chorale and an antiphonal gospel group. Et cetera. The possibilities are many, and, if I may say so, quite exciting.

Index